IMAGES
of America

HISTORIC CEMTERIES
OF NORTHERN VIRGINIA

ON THE COVER: An open gate beckons visitors to enter the Mason family cemetery at Gunston Hall in Fairfax County. Gunston Hall was the home of George Mason IV, a leading figure in the American Revolution. Northern Virginia's cemeteries are time capsules reflecting the region's 350 years of history and offer a glimpse into the lives and fortunes of the famous, infamous, and not-so-famous. (Library of Congress.)

IMAGES
of America

HISTORIC CEMTERIES
OF NORTHERN VIRGINIA

Charles A. Mills

ARCADIA
PUBLISHING

Published by Arcadia Publishing
Charleston, South Carolina

Printed in the United States of America

Library of Congress Control Number: 2015948604

For all general information, please contact Arcadia Publishing:
Telephone 843-853-2070
Fax 843-853-0044
E-mail sales@arcadiapublishing.com
For customer service and orders:
Toll-Free 1-888-313-2665

Visit us on the Internet at www.arcadiapublishing.com

This book is dedicated to Venerable Zen Master Pohwa Sunim.
"Matters of life and death are of great importance."

CONTENTS

Acknowledgments 6

Introduction 7

1. Prince William County 9

2. Fairfax County 35

3. Alexandria 65

4. Arlington National Cemetery 91

5. Art, Symbols, and Philosophy 117

ACKNOWLEDGMENTS

I am extremely grateful for the help of the staffs of the Virginia Room of the Fairfax County Library, the Library of Congress, the Alexandria Library Special Collections branch, and the Ruth E. Lloyd Information Center at the Bull Run Regional Library.

I also gratefully acknowledge the excellent work done by the Fairfax County Cemetery Preservation Association and the Prince William County Historical Commission in cataloging and preserving so many historic cemetery sites in Northern Virginia. I am also indebted to Dr. Pamela Cressey and Alexandria Archaeology for their fine work in documenting and safeguarding Alexandria's historic cemeteries.

I am also grateful for the assistance and support of Lynne Garvey-Hodge of the Fairfax County Historical Commission, Susan Gray of the Fairfax City Museum, Sara B. Anderson of the Prince William County Historical Commission, Don Hakenson, Jon Vrana, Mary Lipsey, and Deborah E. Tronic for her assistance in field research.

Photographs from the Library of Congress are noted as (LOC) and from the author's collection as (AC).

INTRODUCTION

The history of Northern Virginia began long before the arrival of European settlers. The earliest known inhabitants arrived in the area some 13,000 years ago. The first permanent European colonists reached the area in the late 1600s, carving out farms and building small towns. The area prospered in Colonial times, but as relations between Great Britain and its American colonies began to deteriorate, Northern Virginians played a leading role in formulating the grievances against the Crown. George Washington's preeminent fame at the end of the American Revolution set the stage for the future development of Northern Virginia, for it was to him that the country turned to select the site of a new capital city. The rise of the new federal city along the banks of the Potomac River insured that Northern Virginia would always be at the center of the nation's history. This was never clearer than in 1814, when a British army burned the great public buildings of Washington and left the sky aglow. A British flotilla was soon to sail up the Potomac.

From the earliest days of the republic, slavery had been the great indigestible of American life. For decades, politicians had found temporary compromises that averted a violent collision, but ultimately only a long and bloody war could decide the issue. The Civil War was the bloodiest war in American history. Northern Virginia suffered. Crops were trampled. Fences were chopped up for firewood. Livestock was requisitioned. Barns, outbuildings, and private homes were occupied by the armies. Many skirmishes and two major battles were fought on the doorstep of the nation's capital. The sights and sounds of war and preparation for war were constant for four long years. By 1865, after 26 major battles and 400 smaller engagements on her soil, all of Virginia lay prostrate.

The late 19th century in America is often called the Gilded Age. It was an era of unprecedented economic boom, with a few unscrupulous robber barons making enormous fortunes, often unethically, and almost always without regard for the public good. Fearing the power of the unscrupulous rich on the one hand and the growing anger of the poor on the other, middle-class reformers called Progressives banded together to rein in the robber barons and relieve the suffering of the poor. The Progressives advocated a wide range of economic, political, social, and moral reforms aimed at public improvement. Starting at the local level and gradually winning state and then national influence, the Progressives laid the foundations of modern American society.

By the turn of the 20th century, America's population and economy were expanding at a tremendous rate. America was on the verge of becoming a world power. In 1898, war with Spain brought vast new Pacific domains under American control. In 1908, Pres. Theodore Roosevelt sent a US Navy battle fleet, popularly known as the Great White Fleet, around the world on a goodwill mission, which also served to demonstrate the country's growing military power. This power was soon to be tested as the nation entered World War I in 1917.

At the conclusion of World War I in 1918, the pace of change seemed to go into hyper-drive. Women got the vote. Styles became daring. New technology was everywhere. Change accelerated as America entered the Roaring Twenties. Fortunes were made in the stock market, illegal booze flowed freely, and it seemed the good times would never end. They did. On October 29, 1929,

Black Tuesday, the stock market crashed, ushering in the Great Depression, which would last for some 10 years, bringing economic hardship to millions.

"There is a mysterious cycle in human events. To some generations much is given. Of other generations much is expected. This generation of Americans has a rendezvous with destiny." So said Pres. Franklin D. Roosevelt in words that epitomize the nearly 20 years of crisis and trial that faced what has become known as the Greatest Generation. In the 1940s, Americans just emerging from the trials of the Great Depression were called upon to turn back Nazi aggression in Europe and Japanese militarism in Asia.

After four long years of sacrifice and the loss of 300,000 soldiers, America was not long permitted to enjoy the blessings of peace. A new prolonged struggle with international Communism started at the moment the guns of World War II fell silent. A generation would grow to adulthood under the shadow of global thermonuclear war.

Old cemeteries and tombstones tell us much about the lives, tastes, and aspirations of people across the centuries. Northern Virginia's cemeteries are time capsules reflecting the region's 350 years of history and offer a glimpse into the lives and fortunes of the famous, the infamous, and of those who are remembered best for loving their families, tending to their businesses, and supporting their communities quietly and effectively.

There are some 1,000 cemeteries in Northern Virginia, ranging from small family plots to huge national cemeteries covering hundreds of acres. This book is not meant to be an inclusive survey of every cemetery in the region, rather it is a presentation of the history of Northern Virginia through the medium of cemeteries. Northern Virginia is a treasure house of history, perhaps more so than any other part of the country. One unique way of experiencing that history is by visiting one of the region's many historic cemeteries. Every gravestone has a story to tell. Cemeteries have been called open-air museums, and they provide insights not only into past burial customs, religious beliefs, and cultural and ethnic influences but also into community origins, development, and values.

British prime minister William Gladstone once said, "Show me the manner in which a nation or community cares for its dead, and I will measure with mathematical exactness the tender sympathies of its people, their respect for the laws of the land and their loyalty to high ideals." For the most part, Northern Virginia has done an exceptional job in honoring the dead and preserving the nation's historical legacy.

One

PRINCE WILLIAM COUNTY

Prince William County was created by an act of the General Assembly of the colony of Virginia in 1731. The county was a rural community for most of its existence. The population centered in two areas, one at Manassas (home to a major railroad junction) and the other along the Potomac River.

The town of Dumfries became an important port for the export of tobacco, rivaling New York, Philadelphia, and Boston. Dumfries reached its zenith in the 1760s, after which erosion and siltation doomed the once-thriving port.

The railroad era began in Virginia in the early 19th century. In 1851, the railroad reached Manassas Junction, which became an important rail hub and a strategic prize in the Civil War.

By the time of the Civil War, the entire population of Prince William County stood at some 8,500 and was widely scattered throughout the county. In 1860, there were 125 households in the vicinity of Manassas Junction. Most of the 548 whites and 45 free blacks were farmers or farm laborers. Most of the whites were not slave owners, but there were some sizeable estates with slave populations.

During the four years of the Civil War, 26 major battles and 400 smaller engagements were fought in Virginia. The Confederacy erected gun batteries along the Potomac River in the early part of the war, and two of the Civil War's great battles, First and Second Manassas, were fought in Prince William County.

One of Northern Virginia's largest and most enduring military facilities, Quantico Marine Corps Base, was born as a result of America's entry into World War I. The first Marine contingent to arrive consisted of 91 enlisted men and four officers. Soon, thousands would come pouring in for training. There were not enough barracks, and the troops did their laundry in the river. Troops unaccustomed to a Virginia summer complained, "Quantico was hotter than a pistol and muddier than a pigsty."

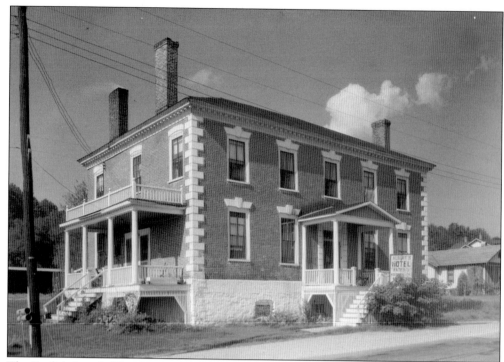

The English founded Jamestown in 1607 and moved steadily northward, displacing the original Native American inhabitants. Both Dumfries and Alexandria were established as towns in 1749 by Scottish merchants. A fierce rivalry between the two ports arose. For about 15 years, Dumfries was a thriving port, shipping tobacco from the interior to England. (LOC.)

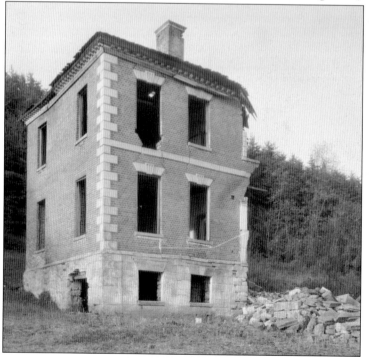

At its height, Dumfries was the second-busiest port in Colonial America, rivaling New York, Boston, and Philadelphia. Erosion and silting ultimately left Dumfries high and dry, while Alexandria carried on significant trade for many years to come. Merchants abandoned Dumfries, and the town fell into decay. Today, Dumfries is a small village. (LOC.)

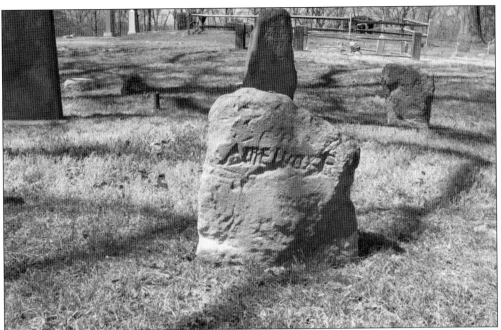

The graves of early settlers can be found in the Dumfries cemetery, formerly the site of the Quantico church founded in Colonial times. The earliest gravestones were often only fieldstones. Some of these, like the one above, were crudely carved with vital information. Many of the earliest stones are now illegible. (AC.)

In September 1781, large numbers of American and French troops marched through Prince William County on their way to Yorktown. Gen. George Washington and the Comte de Rochambeau camped in Dumfries after visiting Mount Vernon. The Dumfries cemetery contains a number of graves dating from the time of the Revolution and early republic. (AC.)

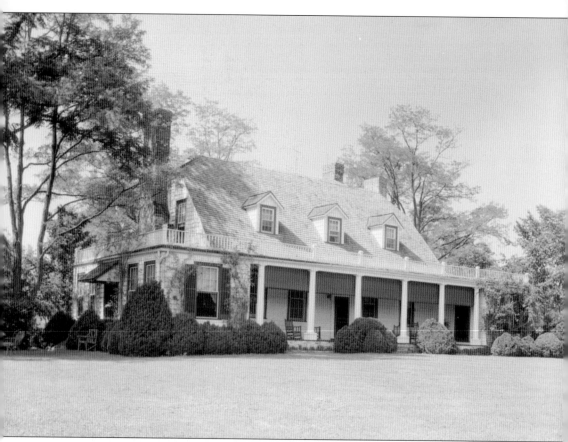

Richard Blackburn was a master builder who built his own house, Rippon Lodge, and the first Truro Parish church at Falls Church. Rippon Lodge is one of the oldest Colonial country houses still standing in Northern Virginia. It is a modest farmhouse compared with the palatial homes of the great patrician Virginia planters, which allows a rare glimpse at the life of the middling folk of the 18th century. It was to master builder Richard Blackburn that George Washington's father turned in 1735 to build a house on a bluff overlooking the Potomac River, the house that was later to be known as Mount Vernon. The survival of this early structure within the fabric of the present Mount Vernon is confirmed by a diarist who in 1801 identified the central portion of the house as having been "constructed by the General's father." (LOC.)

Martin Scarlett was a member of the Virginia House of Burgesses from 1680 to 1695. In the late 1600s, Scarlett acquired Burbage's Neck, which included the land where Rippon Lodge is now situated. His large grave markers were removed from their original location but later recovered and are now in the cemetery at Rippon Lodge. (LOC.)

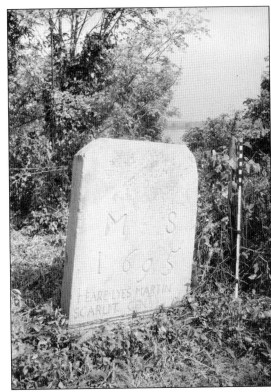

The previous photograph, taken during the mid-1930s, shows Martin Scarlett's gravestone in good condition after almost 250 years of natural weathering. This recent photograph shows the impact of 80 years of pollution on the gravestone, as the area has become more urban. More acid rain–causing pollutants are released over urban areas. (AC.)

One of the oldest tombstones in Northern Virginia dates from 1690 and belongs to Rose Peters, buried at Rippon Lodge. The inscription reads, "She is gone, o she is gone to everlasting rest, to Christ our beloved Savior who loves sinners best." Peters was expelled from Middlesex, England, in 1685 for behavior unacceptable to her neighbors. (AC.)

The Blackburns of Rippon Lodge were prominent Colonial gentry. One tombstone in the family cemetery reads, "Here lieth the Body of Col. Richard Blackburn" who died July 15, 1757, "Preferred by the Governor to the Most Eminent Stations and Command in the Colony." The tombstone notes that Blackburn was a man of consummate prudence, frugality, and industry, "whereby he made a large fortune in a few years." (AC.)

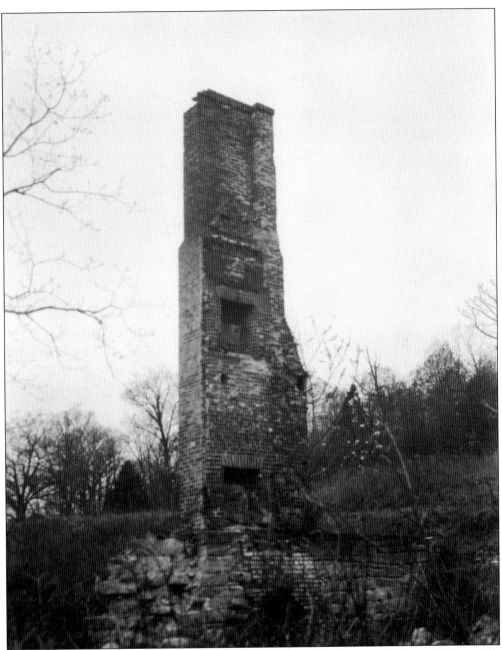

In 1985, Leesylvania State Park was dedicated. Leesylvania (which means Lee's woods) has a rich history dating back to early settlements by Native Americans. The former house site of Henry Lee II, father of Revolutionary War hero Henry "Light-Horse Harry" Lee and grandfather of Robert E. Lee, is on the park's grounds. The plantation is now in ruins. The Lee-Fairfax family cemetery is accessible by trails in the park. The Lee family established the cemetery with the death of Henry Lee II in 1787. His wife, Lucy Lee, the only other member of the Lee family to be buried here, died in 1792. Capt. Henry Fairfax, who purchased the plantation from the Lees in 1825, and his third wife, Elizabeth, are buried in the enclosed portion of the cemetery. Captain Fairfax died in October 1847. Elizabeth died one month later. (LOC.)

William Grayson served during the Revolutionary War as an aide-de-camp to Gen. George Washington, was a member of the Continental Congress, and also as one of Virginia's first senators. Grayson died in Dumfries on March 12, 1790, the first member of Congress to die in office. He was interred in the Grayson family vault in Woodbridge on a hill overlooking Marumsco Creek. The family burial vault was originally located on a 1,000-acre plantation. Now, less than five acres remain undeveloped. The burial vault, now sitting in the midst of a Woodbridge residential neighborhood, was encased in concrete in the early 1900s by the Daughters of the American Revolution and has recently been repaired. The Reverend Spence Grayson, a "fighting parson" of the Revolution and lifelong friend of George Washington, is also buried in the vault. (AC.)

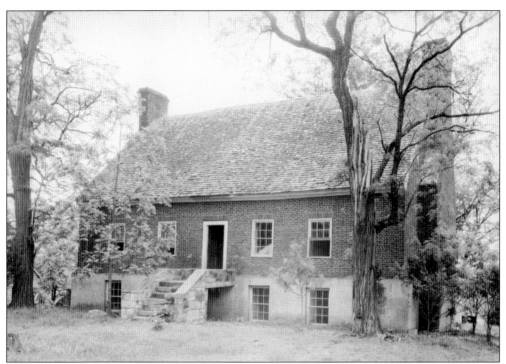

Mason Locke Weems (1759–1825), known to history as Parson Weems, was buried at Bel Air Plantation. An author, bookseller, and preacher, Weems in 1800 invented the famous story of George Washington and the cherry tree, which includes the line, "I cannot tell a lie, I did it with my little hatchet." (LOC.)

Weems wrote biography to amplify his subject. His subject was "Washington, the hero, and the demigod." Weems also wrote biographies of Francis Marion (the Swamp Fox), Benjamin Franklin, and William Penn. It has been said of his writing, "If the tales aren't true, they should be. They are too pretty to be classified with the myths." (LOC.)

He writhes, he gnashes his teeth. On bended knees he curses the authors of his ruin. Poor

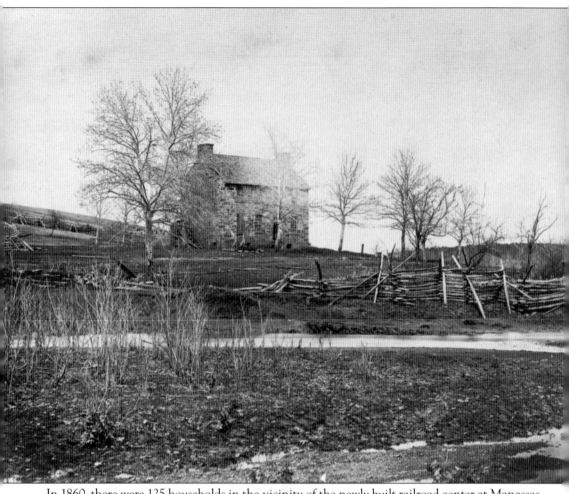

In 1860, there were 125 households in the vicinity of the newly built railroad center at Manassas Junction. Many of these households were linked by blood or marriage. Kinship was a central concern of these Virginia farmers. Marriage, remarriage, and intermarriage among neighboring families created extensive family ties. Most of the 548 whites and 45 free blacks were farmers or farm laborers. Most of these farmers belonged to the class of small farmers who tilled their own fields, usually without any help except from their wives and children. In Virginia, only 25 percent of the landowners were slaveholders. Membership in the planter class required ownership of at least 20 slaves: 88 percent of all Virginia slaveholders had fewer than 20 slaves, and 50 percent held fewer than five slaves.

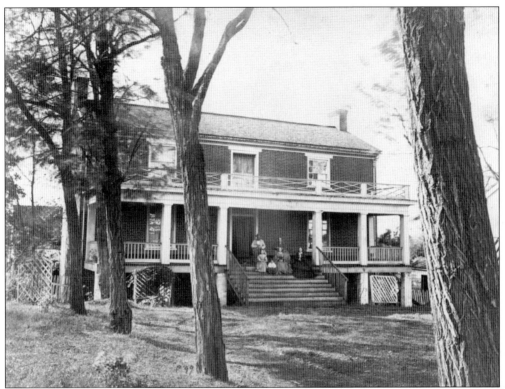

The Civil War virtually began in Wilmer McLean's kitchen in Manassas on July 18, 1861, when a Union shell dropped into the chimney and exploded in a pot of stew. McLean moved his family to central Virginia, out of harm's way, only to have his house chosen for the surrender of Robert E. Lee in 1865. The McLean house at Appomattox is seen here. (LOC.)

After the war, McLean still owned hundreds of acres in northern Virginia, but the land was worthless for resale. Eventually, McLean turned to politics, joined the Yankee Republican party, supported Grant in the election of 1872, and was rewarded by an appointment to a US Treasury position. He is buried in St. Paul's Cemetery in Alexandria. (AC.)

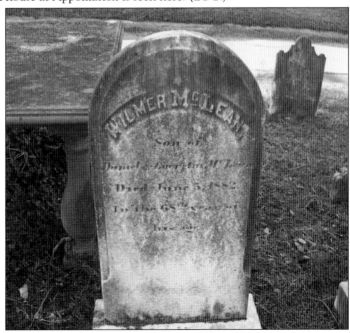

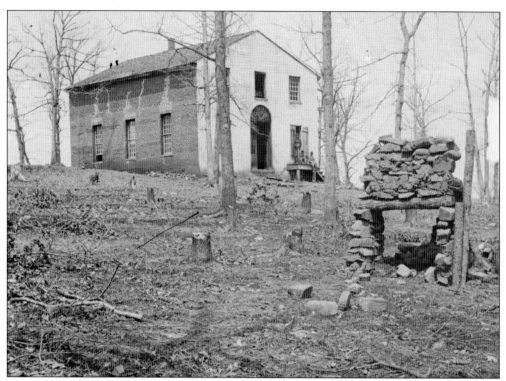

Services were abruptly cancelled at Sudley Church near Manassas when 15,000 Union troops began crossing nearby Sudley Springs Ford on the morning of Sunday, July 21, 1861. The building became a Union army field hospital and quickly filled with the wounded and dying. The diarist Maj. Sullivan Ballou of the 2nd Rhode Island Regiment was among those who died at Sudley. (LOC.)

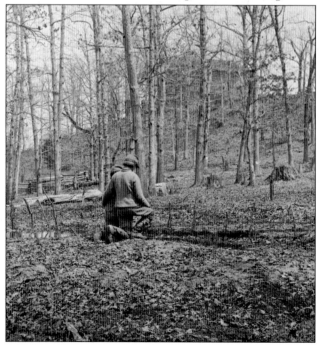

Boys kneel at a crude battlefield grave near Sudley Church. Most soldiers in the Civil War died of disease rather than in battle. For many, army life was the first time they had come in proximity to large groups of people, and the soldiers had no immunity to diseases such as chickenpox, smallpox, scarlet fever, measles, and mumps. (LOC.)

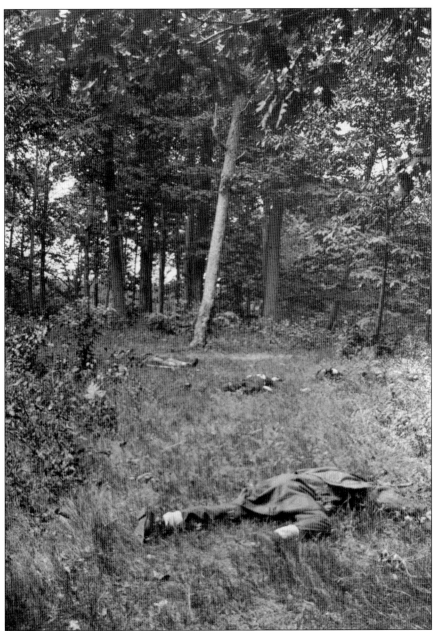

When President Lincoln called for 75,000 volunteers in April 1861 to put down the rebellion, rebel jokers published advertisements for "75,000 Coffins Wanted." Bill Arp, a popular Georgia humorist, wrote a letter to President Lincoln thoughtfully worrying that the Union's military strategy might be "too hard upon your burial squads and ambulance horses." The First Battle of Manassas was fought on July 21, 1861. The next day dawned through clouds. It drizzled early and in the afternoon rained heavily. Many dead and wounded still lay on the field. The Confederate Ambulance Corps found dead men in every conceivable position, mangled, dismembered, disemboweled, some torn literally to pieces. Some in their death struggles had torn up the ground around where they fell. Others had pulled up every weed or blade of grass that was in their reach. Soldiers were often buried in shallow makeshift graves. (LOC.)

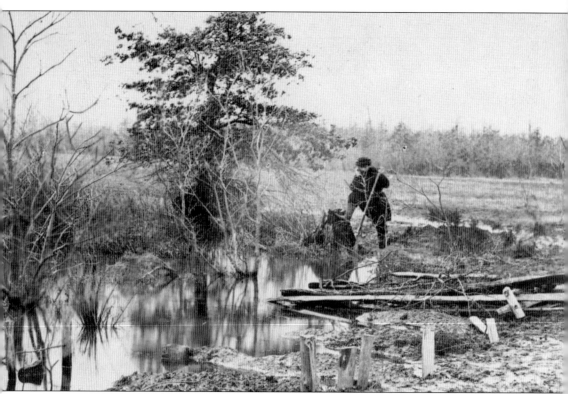

Before the Civil War, a freed slave named Jim Robinson operated a drover's tavern along the Alexandria and Warrenton Turnpike. Eventually, he was able to purchase his wife and three of his five children as well as buy several hundred acres of land. The Robinson family continued to work their farm after the war. The farm was sold to the Department of the Interior in 1934 to become part of the Manassas National Battlefield. For many years prior to selling their farm, the Robinson family acted as informal stewards of their part of the battlefield, taking Confederate remains to a small cemetery to join an estimated 500 unknown soldiers. The family philosophy was summed up in the phrase, "Just remember, these remains belonged to someone's son who did not want to die in this manner." As late as the 1920s, the family was still finding remains. (LOC.)

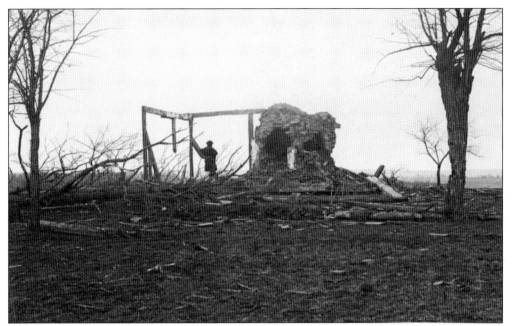

As the First Battle of Manassas began, 84-year-old invalid Judith Henry lay in her bed. Shells from Union artillery began to fall around the widow's house, Spring Hill (ruins pictured). A shell burst in the room where she lay. She was struck by seven shell fragments and lived for several agonizing hours, dying about nightfall. She was buried next to her house. (LOC.)

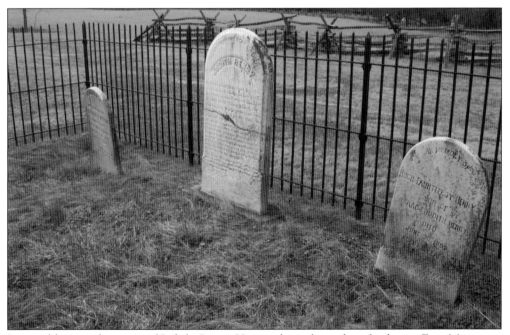

Pictured here is the grave of Judith Carter Henry, the only civilian fatality at First Manassas. Judith Carter was born at Pittsylvania in 1777 in the midst of the Revolutionary War. She was the daughter of Landon Carter, who inherited the plantation in direct descent from Robert "King" Carter. In 1801, she married Dr. Isaac Henry, one of the first surgeons in the US Navy. (AC.)

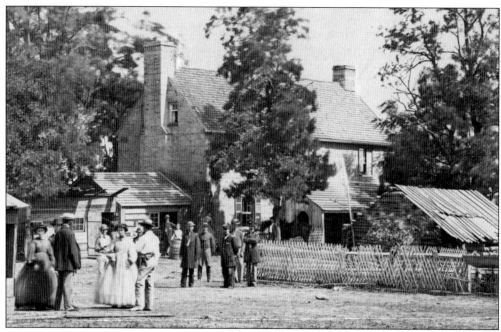

After the battle, many homes like the one seen here became grisly field hospitals. The wounded, dead, and dying covered every floor. There were piles of amputated legs, feet, hands, and arms, all thrown together. At a distance, they looked like piles of corn. The dead were buried in nearby gardens. (LOC.)

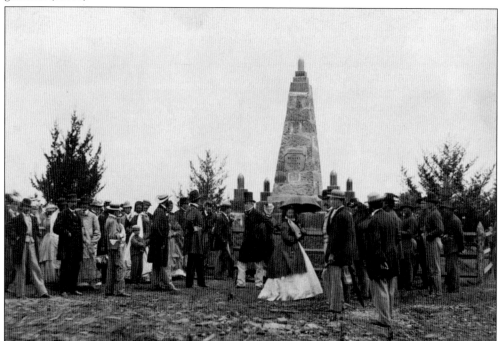

The original Henry House was completely destroyed during the war, but the Henry family built a new home on the site in the 1870s. A stone obelisk to the east of the house honors the Union dead. Erected in June 1865, it is one of the earliest Civil War battlefield monuments. (LOC.)

Folly Castle was a house in the line of battle, about a mile from the Henry House. Betty Leachman put her five small children under a large sideboard until the firing ceased late in the evening. Early on the morning after the battle, young Hugh Henry, from Henry House, came over saying his mother had been wounded during the battle and had died in the night. He asked Leachman and her sister-in-law to return with him to prepare her body for burial. They went, cutting across fields strewn with dead soldiers. They stayed until Judith Henry had been buried. After the war, Hugh continued living at Spring Hill, which was rebuilt. He became a teacher and later in life acted as an informal steward and guide over his portion of the battlefield. He placed rough board signs on some of the trees and posts of the farmyard and pastures, describing the main sites of interest. He is buried next to his mother. (LOC.)

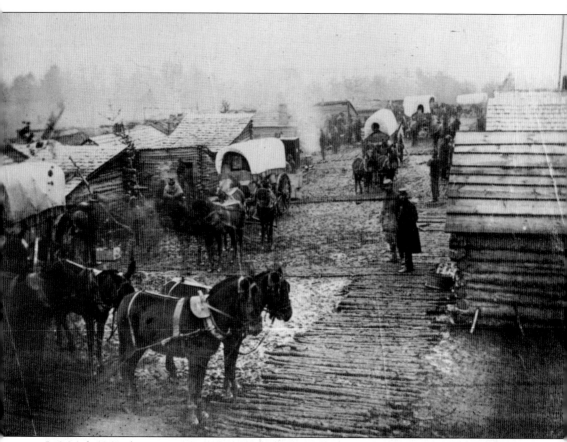

In March 1862, the new commander of the Union army, George B. McClellan, devised a strategy whereby the Union army would move down the east side of the Potomac River, cross over into Virginia, and capture Richmond while the Confederate army was still far to the north. The Confederates, under Joseph B. Johnston, prepared to counter the new Union offensive, evacuating Manassas and the defensive line along the Occoquan River. Heavy rainfall throughout the winter rendered the roads practically useless, and the use of wagons to transport the surplus supplies became impossible. The retreating Confederates left large quantities of supplies behind, which were quickly looted by the Federals. Soldiers of the 1st Massachusetts Regiment came upon some fresh graves marked with warnings against disturbing the dead. The Yankee soldiers ignored the warnings. Instead of bodies they found new tents, uniforms, well-equipped mess chests, and other equipment. (LOC.)

North central Virginia became the preserve of one of the most dashing figures of the war, Col. John Singleton Mosby. Northern Virginia was an ideal area for cavalry operations, and in the last three years of the war, Mosby's horsemen so dominated activities in the area that it was often called "Mosby's Confederacy." (LOC.)

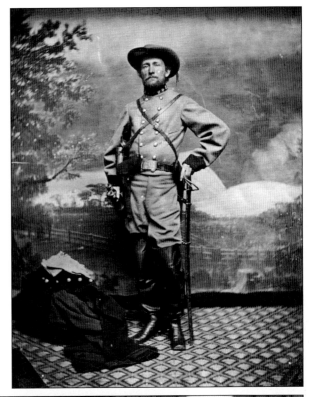

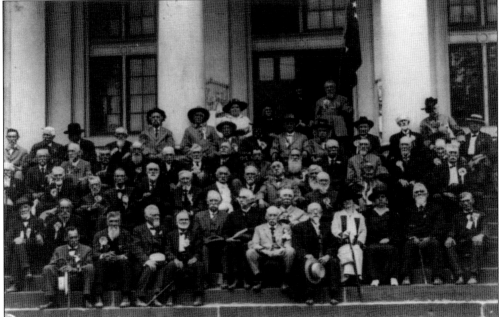

Mosby immobilized 30,000 Union troops. His command, often consisting of fewer than 50 men, captured thousands of Union troops, horses, and mules. Soon, civilians in the area became conscious of the Mosby magic and offered to enlist under the Confederate law that authorized the creation of guerilla bands. Mosby veterans are seen here at a 1918 reunion. (LOC.)

Mosby continued his activities unabated right to the end of the war, never officially surrendering to Federal forces. Mosby died in 1916 at the age of 83 and is buried in Warrenton, Virginia. The graves of Mosby's raiders can be found in many area cemeteries, such as this one in Greenwich. (AC.)

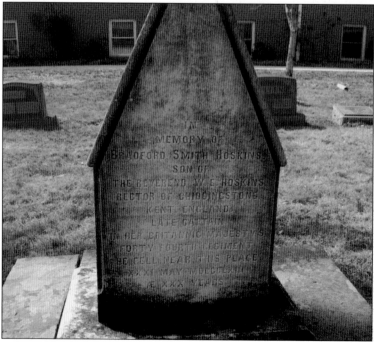

A poignant reminder of the Civil War is the gravestone of Bradford Smiths Hoskins at Greenwich: "Late Capt. in her Britannic Majesty's Forty Fourth Regiment," a British officer fighting under the command of Colonel Mosby. It was not unusual to find British officers visiting or even fighting with the opposing armies. (AC.)

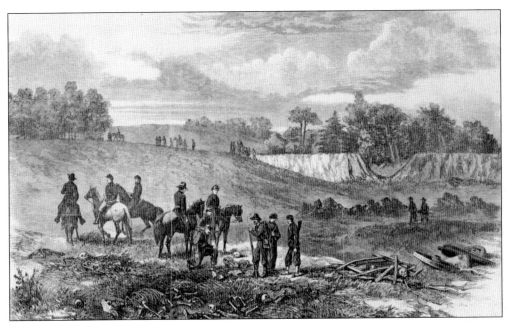

Shortly after the Civil War, the US government launched a widespread effort to locate and rebury Union soldiers. By 1870, over 90 percent of the Union casualties, almost half of whose identities were unknown, were interred in national cemeteries, private plots, and post cemeteries. No such government effort was made for Confederate dead. (LOC.)

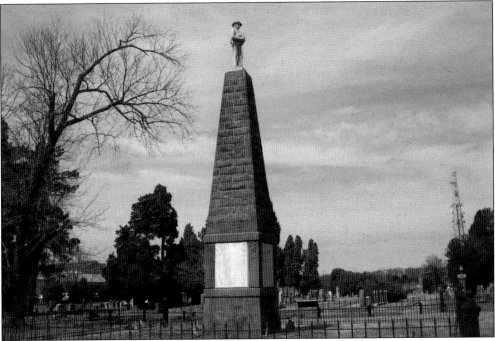

The remains of 250 Confederate soldiers were reinterred in a one-acre section of the Manassas Town Cemetery shortly after the war. Nearly all had died from disease. The bodies were recovered from original gravesites on surrounding farms. The 75-foot red sandstone monument, built by J.R. Tillet, was dedicated on August 30, 1889. (AC.)

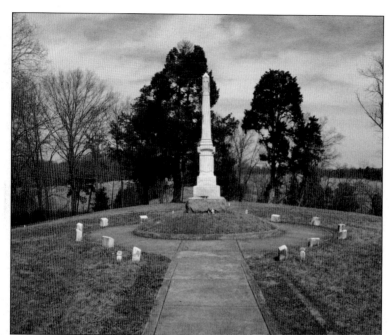

The Confederate cemetery at Groveton was established in 1869 by the ladies of the Groveton and Bull Run Memorial Association. At least 266 Confederate dead were reinterred here after the war. The monument to the Confederate dead in the center of the cemetery was dedicated on August 30, 1904. (AC.)

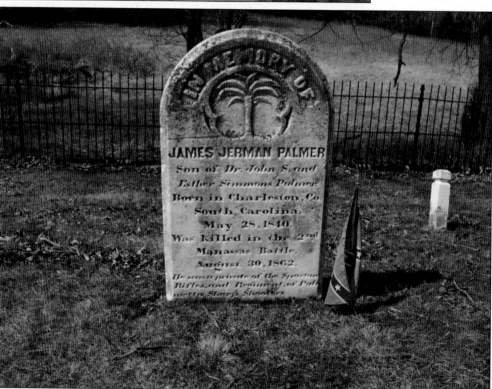

Most of the dead at the Groveton cemetery are unidentified. Only two graves have marked headstones: Pvt. William G. Ridley, 6th Virginia Infantry, and Pvt. James J. Palmer, Palmetto Sharpshooters. Both men were killed on August 30, 1862, during the Second Battle of Manassas. The National Park Service acquired title to the cemetery in 1973. (AC.)

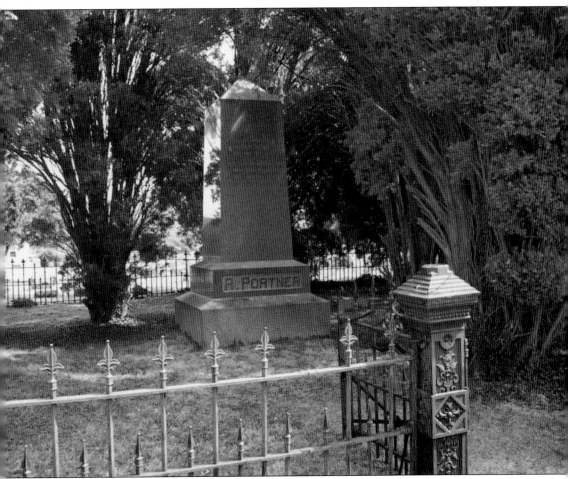

Pictured here is the grave of Robert Portner (1837–1906) at the Manassas City Cemetery. During the Civil War, Portner established a brewery to meet the needs of thirsty soldiers. After the war, Portner expanded the operations of the brewery, built an ice plant, bought a shipyard, started a construction company, speculated in real estate, and established a bank. In 1880, Portner invented an early air-conditioning device that used steam-driven fans to force air over refrigerated pipes. By 1895, the brewery was so successful, Portner took on investors and formed the National Brewing Company, a major rival to Anheuser-Busch and the largest brewery in the South. In 1892, Portner built a mansion called Annaburg. Modifying the cooling system he had invented for the brewery, Portner was able to make Annaburg what is believed to be the first air-conditioned house in America. Robert Portner died at Annaburg in 1906, rich, celebrated, and loved, surrounded by his family. (AC.)

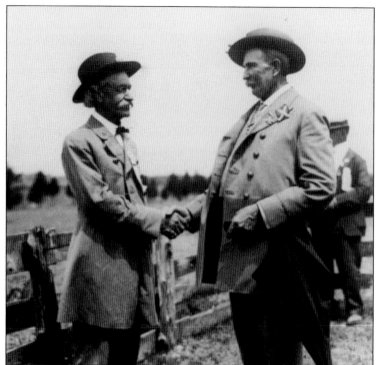

In July 1911, the town of Manassas hosted a peace jubilee to mark the 50th anniversary of the Civil War's first great battle. George Carr Round, a Union veteran who settled in Manassas, is credited with this gesture of reconciliation. Round was later instrumental in the establishment of the Manassas National Battlefield Park. (LOC.)

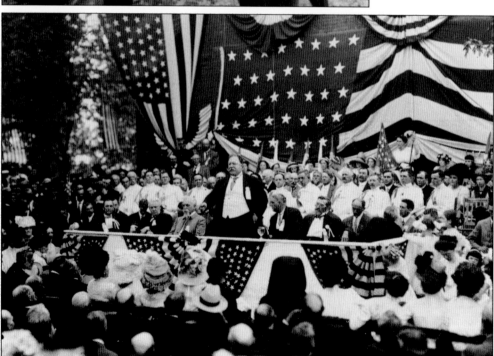

At noon on July 21, 1911, the 50th anniversary of the Battle of Manassas, the veterans moved to the top of Henry Hill. When the signal was given, the veterans marched forward with hands outstretched. For five minutes, they shook hands. The day was capped off by an address by President Taft. (LOC.)

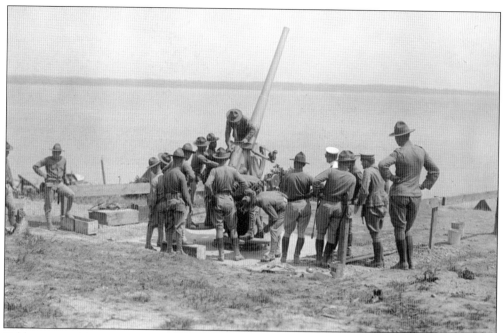

Told to expand its training capabilities during World War I, the Marine Corps began inspecting promising sites in the spring of 1917. Some 5,000 acres along Quantico Creek were leased. In 1918, a permanent Marine base was established at Quantico. Marines are seen here along the Potomac River in 1918. (LOC.)

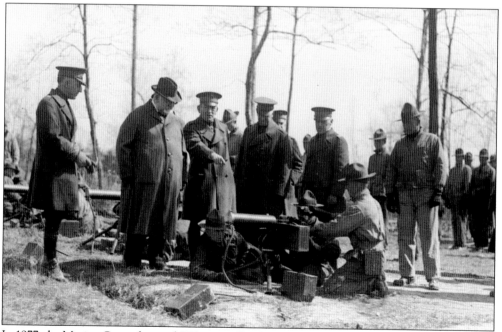

In 1977, the Marine Corps donated 725 acres of land to establish the Quantico National Cemetery. The cemetery was formally dedicated on May 15, 1983. The land has been used by the military for over 200 years: first around 1775 by the Commonwealth of Virginia for Navy operations and later as a blockade point for the Confederate army during the Civil War. (LOC.)

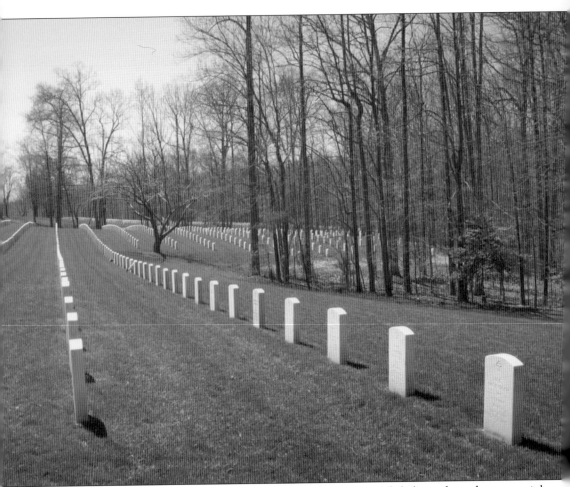

In 1989, a monument to Edson's Raiders was the first memorial dedicated on the memorial pathway at Quantico National Cemetery. It is dedicated to the 800 members of the 1st Marine Raider Battalion, which from August 1942 to October 1943 played a key role in helping the greatly outnumbered American forces push back Japanese troops in the Solomon Islands. The Purple Heart Memorial was dedicated on August 7, 1990, in honor of Purple Heart recipients interred at the cemetery. Additional memorials honor Col. William "Rich" Higgins, who was held hostage in Lebanon; the 4th Marine Division Memorial; the Commonwealth of Virginia Memorial dedicated to honor all of the nation's veterans; the 1st Marine Division Memorial; and the 6th Marine Division Memorial to honor the division that won the Presidential Unit Citation for its actions in Okinawa during World War II. This memorial design is based on a Japanese tomb. (AC.)

Two

FAIRFAX COUNTY

Fairfax County was formed in 1742. Throughout the mid-18th century, the county was largely a wilderness. It had few roads and virtually no industry. The only wealth and commerce came from cultivation of tobacco with slave labor.

During the last half of the 18th century, two of the county's most prominent residents, George Washington and George Mason, became chief forces behind the formation of the new American nation. While Washington, as commander-in-chief of the victorious Continental army, was the most important figure of the Revolutionary War, George Mason was a major force in molding the American vision of freedom. Mason's Virginia Declaration of Rights served as the model for the American Bill of Rights.

After the Revolution, the selection of the site of the new country's capital was greatly influenced by Washington's being a resident of Fairfax County.

By the mid-19th century, sectional differences erupted into civil war. During the early days of the Civil War, Confederate troops held much of the county, but Union troops were positioned in the northern and eastern areas. Several minor engagements occurred in Fairfax County early in the war. On September 1, 1862, following the Battle of Second Manassas, the Battle of Ox Hill (also called the Battle of Chantilly), the only major Civil War battle to take place in Fairfax County, was waged across 500 acres of farmland. After Second Manassas and the Battle of Chantilly, Union and Confederate wounded were brought to St. Mary's Church in Fairfax Station to be cared for by Clara Barton, who later founded the American Red Cross.

Once the war came to an end in April 1865, the economic rebuilding of the county began, but Fairfax County would remain mainly rural until the mid-20th century. From 1790 to 1930, the county's population doubled from 12,300 to 25,000. From 1930 to 1950, the population quadrupled from 25,000 to almost 99,000 people. The county's population has increased by a magnitude of 10 since 1950 to more than one million people today.

Perhaps the most venerated tomb in America is that of George Washington. Washington died on December 14, 1799. Congress resolved to build a marble monument in the new Capitol. Martha Washington granted her consent. A crypt was provided under the dome of the Capitol, but the project was never completed. (LOC.)

At 10:00 p.m. on December 14, 1799, George Washington, fearing premature burial, requested of his doctors to be "decently buried" and to "not let my body be put into the Vault in less than three days after I am dead." In his last will, he expressed the desire to be buried at Mount Vernon. (LOC.)

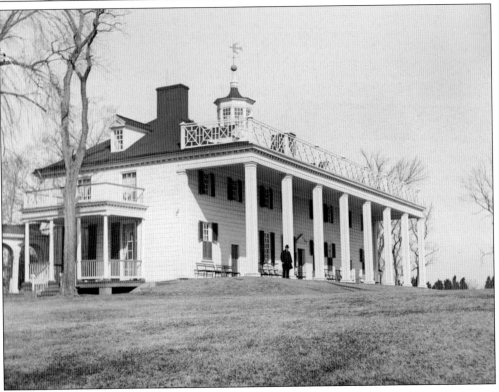

George Washington was entombed in the existing family vault (seen here), now known as the old vault, on December 18, 1799. Visitors wrote that the tomb was "a low, obscure, ice house looking brick vault," which "testifies how well a Nation's gratitude repays the soldier's toils, the statesman's labors, the patriot's virtue, and the father's cares." (LOC.)

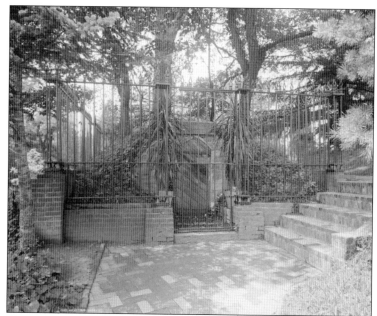

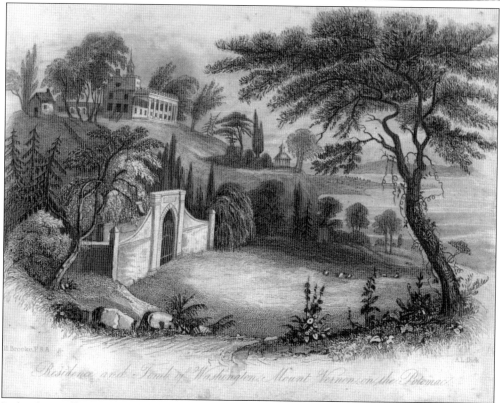

In his last will, George Washington directed the building of a new family burial vault in the following words: "The family Vault at Mount Vernon requiring repairs, and being improperly situated besides, I desire that a new one of Brick, and upon a larger Scale, may be built at the foot of what is commonly called the Vineyard Inclosure." (LOC.)

THE SPIRIT OF THE UNION.

PUBLISHED BY CURRIER & IVES Copyright 1876 by Currier & Ives, N.Y. 125 NASSAU ST. NEW YORK.

Lo! on high the glorious form, Americans your Fathers shed
Of Washington lights all the gloom, Their blood to rear the Union's fane,
And words of warning seem to come Then let your blood as free be given,
From out the portal of his tomb; The bond of Union to maintain.

In 1831, Washington's body was transferred to the new tomb. A French visitor wrote that Mount Vernon had become "like Jerusalem and Mecca, the resort of the travelers of all nations who come within its vicinity." Visitors were filled with "veneration and respect," leading them "to make a pilgrimage to the shrine of patriotism and public worth." Pilgrims from across the country converged on Mount Vernon during the early 19th century. Veterans of the American Revolution connected deeply to Washington through the pilgrimage. Many pilgrims, overwhelmed with emotion, wept. Thomas Cope, an early diarist, recounted the following, "One placed himself on the green turf and mused, with his head resting on his arms. Another stood alone among the thicket with folded arms and downcast eyes. A third reclined against a tree and wept . . . there was nothing artificial in this, nothing premeditated." (LOC.)

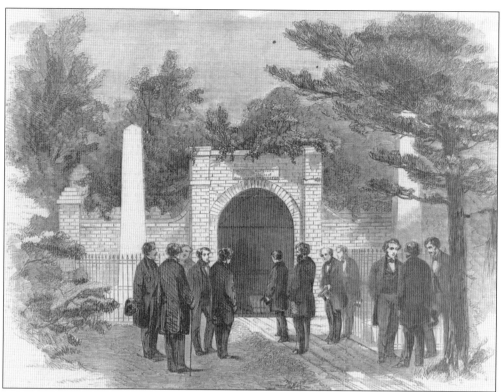

On October 5, 1860, Pres. James Buchanan accompanied the Prince of Wales (later King Edward VII) on a tour of Mount Vernon and visited Washington's tomb. British correspondent Nicholas Woods wrote, "No pious care seems to have ever tended this neglected grave . . . It is here alone in its glory, uncared for, unvisited, unwatched, with the night-wind for its only mourner sighing through the waste of trees." (LOC.)

On November 13, 1919, the future King Edward VIII visited Washington's grave. The prince planted a small English yew tree near the tomb. On March 18, 2015, HRH Prince Charles, the Prince of Wales, and his wife, Camilla, Duchess of Cornwall, laid a wreath at the tomb. The tree planted by his great uncle was pointed out to the prince. (LOC.)

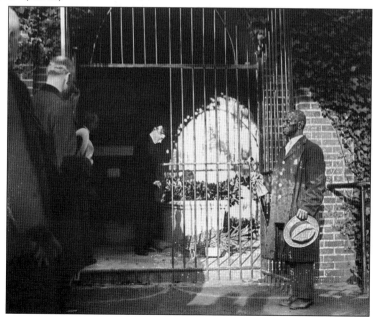

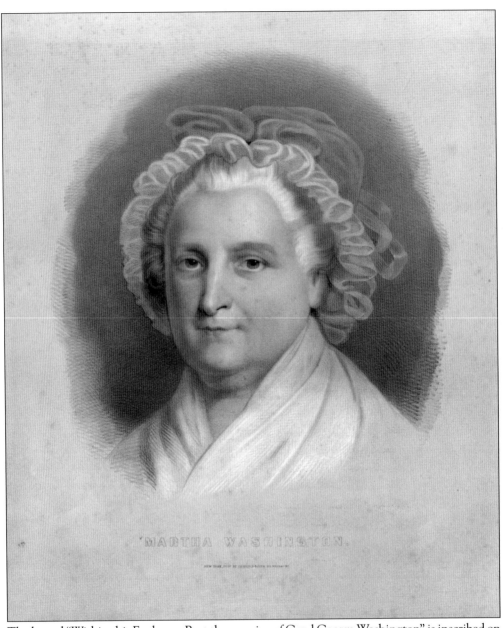

MARTHA WASHINGTON.

The legend "Within this Enclosure Rest the remains of Gen.l George Washington" is inscribed on a stone tablet over the entrance to the tomb. Behind an iron gate are two marble sarcophagi, one inscribed "Washington," the other "Martha, Consort of Washington." The marble sarcophagus in which the body of General Washington now rests was erected in 1837. The remains of Martha Washington reside in a similar but plainer sarcophagus. After Washington's death, the 68-year-old Martha closed up the second-floor bedroom that she had shared with her husband and moved to a room on the third floor. She turned increasingly to religion, spending part of every day in religious study. Visitor Sally Foster Otis remarked in 1801, "She speaks of death as a pleasant journey." Martha Washington died 2.5 years after her husband on May 22, 1802. (LOC.)

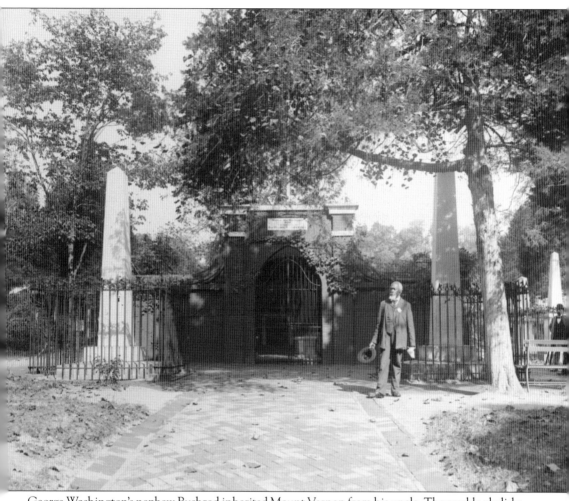

George Washington's nephew Bushrod inherited Mount Vernon from his uncle. The marble obelisks in front of the tomb were erected to the memory of Bushrod Washington and his nephew John Augustine Washington, who in turn were the masters of Mount Vernon. Both are buried in the inner vault together with many other members of the family. Bushrod was the favorite nephew of Pres. George Washington. In 1802, upon the death of his aunt Martha Washington, he inherited Mount Vernon. Bushrod spent 31 years as an associate justice of the Supreme Court and died in 1829. When Bushrod died, he left Mount Vernon to his nephew John Augustine Washington, who survived Bushrod by just three years. In 1850, his widow, Jane, conveyed Mount Vernon to their son John Augustine Washington Jr., who was the last private owner of the estate. (LOC.)

Near George Washington's tomb are the unmarked graves of some 150 slaves, including William "Billy" Lee, Washington's personal servant during the Revolutionary War. Lee was freed in Washington's will for "his faithful services during the Revolutionary War" and received a substantial pension and the option of remaining at Mount Vernon. He lived on at Mount Vernon until his death in 1828. Another slave buried here, West Ford, is claimed by some to be George Washington's illegitimate son. According to Linda Allen Bryant, a direct descendant of Ford, there is an oral tradition in the Ford family indicating that West Ford was the child of George Washington and a slave named Venus. At the present development stage of DNA science, no direct link to George Washington can be established. The Mount Vernon Ladies Association has pledged its cooperation with testing as DNA science progresses. (AC.)

Here, descendants of Washington's slaves gather at the memorial dedicated to their ancestors. When Washington died, there were some 317 slaves living at Mount Vernon. Under the terms of Washington's will, his slaves (not including 40 who were rented or the 154 slaves belonging to Martha Washington) were to be freed upon the death of his wife. The terms of the will created an almost immediate problem for Martha Washington. The only thing standing between 123 slaves and their freedom was her life. According to a letter by Abigail Adams, Martha Washington "did not feel as tho her Life was safe in their [slaves] Hands." Nor was this fear groundless. The records of Colonial Virginia document the trial of 180 slaves tried for poisoning. Martha Washington freed Washington's slaves within a year after his death. She never freed her own slaves. (LOC.)

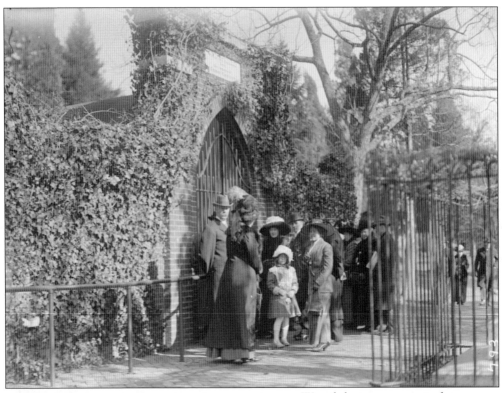

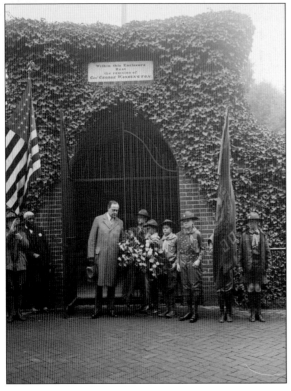

Wreath-laying ceremonies have always been important and continue to be held daily by patriotic, civic, and citizen's groups. Wreath-laying ceremonies consist of the Pledge of Allegiance, General Washington's prayer for his country, and the placement of a wreath, by no more than two participants, within the locked tomb area. Some one million visitors view the tomb annually. (LOC.)

Boy Scouts repeat George Washington's prayer for America: "Almighty God; we make our earnest prayer that Thou wilt keep the United States in Thy holy protection, that thou wilt incline the hearts of the citizens to cultivate a spirit of subordination and obedience to government; and entertain a brotherly affection and love for one another." (LOC.)

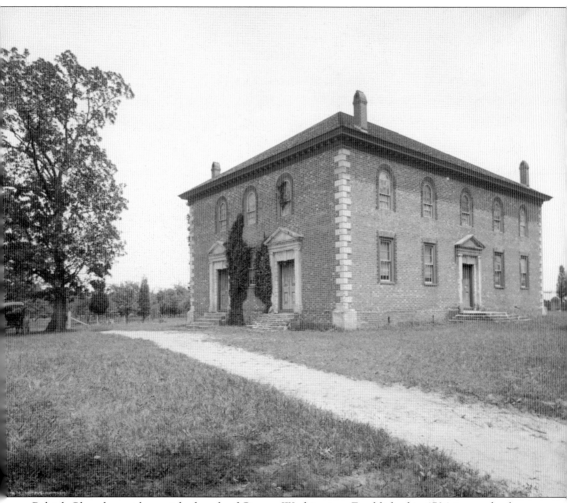

Pohick Church was the parish church of George Washington. Established in 1724, it was the first permanent church in the colony of Virginia. Until the late 19th century, burials in the church yard were unrecorded. In 1886, the cemetery was organized into lots. A perpetual memorial garden was later created for the burial of cremated remains. The Reverend Lee Massey, Pohick's second rector and a close friend of the Washingtons, once wrote, "I never knew so constant an attendant at Church as [Washington]. And his behavior in the house of God was ever so deeply reverential that it produced the happiest effect on my congregation, and greatly assisted me in my pulpit labors. No company ever withheld him from Church. I have been at Mount Vernon on Sabbath morning when his breakfast table was filled with guests; but to him they furnished no pretext for neglecting his God." (LOC.)

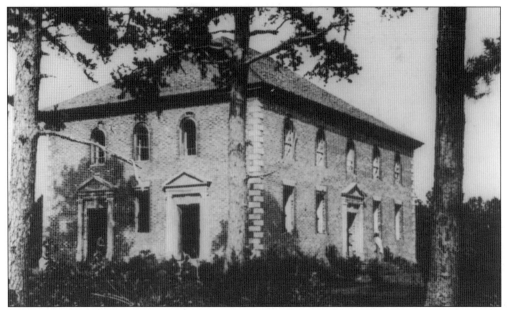

During the Civil War, occupying Union forces stripped the church for souvenirs of Washington's church and used it as a stable. Lt. Charles B. Haydon from Michigan wrote, "I have long known that Mich 2nd had no fear or reverence as a general thing for God or the places where he is worshiped . . . I believe our soldiers would have torn the church down in 2 days." (LOC.)

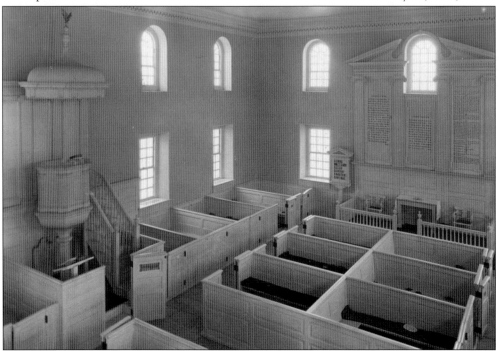

Lieutenant Haydon continued, "They were all over it in less than 10 minutes tearing off the ornaments, splitting the woodwork and pews . . . They wanted pieces to carry away . . . A more absolute set of vandals than our men can not be found on the face of the earth. As true as I am living I believe they would steal Washington's coffin if they could get to it." (LOC.)

Benjamin Lewis, a black servant on a plantation in what is now Prince William County, filed a complaint in the county court on May 20, 1691. Lewis claimed that he was free in England and came to Virginia under a contract to serve four years, just as white indentured servants did. His master, William Harris, claimed the paper was forged. The jury found that the contract was valid and ordered Lewis's release. The case was appealed, but the final decision has been lost. Harris died on May 16, 1698, and was buried near the banks of the Neabsco Creek on land that he had patented in 1669. His tombstone (seen here) is ornately carved and was originally a table style, elevated on four corner leg-posts. The gravestone was removed from its original site because of highway construction and moved to Pohick Church in 1953. (AC.)

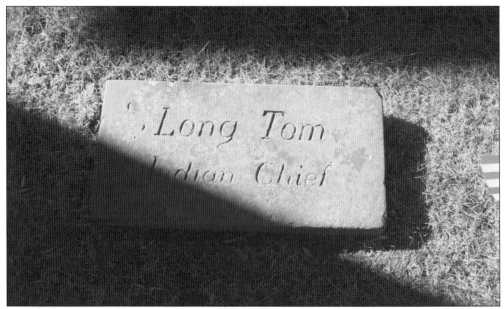

According to legend, an Indian chief named Long Tom was shot and killed by Susanna Alexander either in self-defense or to save the life of her husband, John. According to press accounts from the 1950s, Long Tom was an Orinoco chief (although in Virginia this is the name of a tobacco, not a native tribe). (AC.)

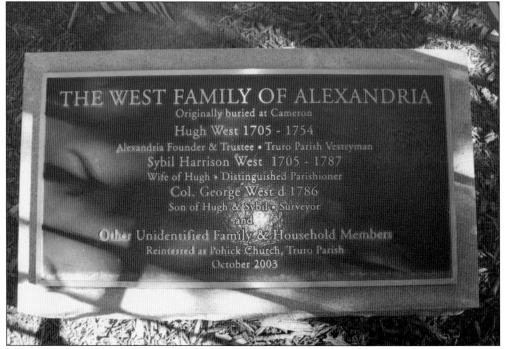

The Wests were founders of Alexandria. Their large landholdings were swallowed up as Alexandria grew. The family burial vault was discovered prior to commercial development of the land. At least seven individuals had been buried in the vault, and additional graves were found outside of the vault. All were reinterred at Pohick Church in 2003. (AC.)

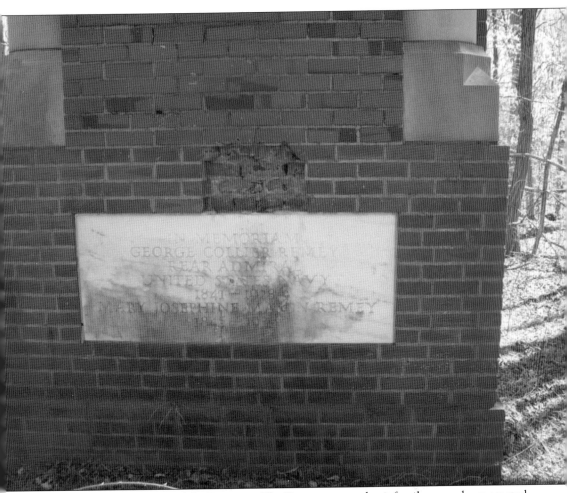

IN MEMORIAM
GEORGE COLLIER REMEY
REAR ADMIRAL
UNITED STATES NAVY
1841 – 1928
MARY JOSEPHINE MASON REMEY
18__ – 18__

Pictured here are the ruins of the Remeum. The Remeum was a huge family mausoleum erected on land belonging to Pohick Church by controversial Baha'i faith leader Charles Mason Remey. The Remeum was constructed over a 20-year period (1937–1958) until a disagreement between the Pohick Church and Remey resulted in legal action. The mausoleum was designed by Remey as a memorial to his family's contributions to America. According to the *Washington Evening Star and Daily News* of April 9, 1973, the mausoleum was planned as a "magnificent complex of walled courtyards, underground chambers with soaring vaulted ceilings, marble reliefs and statues, carved pillars, chapels and burial vaults." Remey devoted most of his fortune to building this burial complex. Some two million bricks were used in its construction. Remey planned to build a huge three-story structure above the underground mausoleum, which would have dwarfed Pohick Church. (AC.)

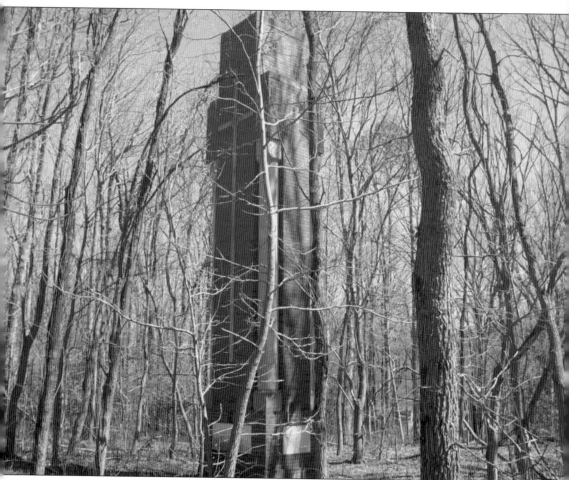

Pictured here are the ruins of the Remeum. The completed sections of the Remeum complex included outer courtyards, an atrium, and the underground mausoleum. Costing millions of dollars, the complex featured bas-reliefs and sculptures by the famous American sculptor Felix de Weldon, who created the iconic flag-raising Iwo Jima US Marine Corps Memorial located in Rosslyn, Virginia. There were also sculptures by other artists decorating the various tombs, alcoves, and hallways of the gargantuan structure. Historic events in which the Remey family participated, from the landing of the Pilgrims to Pearl Harbor, were depicted. Two massive sleeping lions sculpted by Felix de Weldon guarded the entrance to the mausoleum. Inside the memorial chapel were life-size statues depicting faith and charity. Another series of carved reliefs illustrated the lives of saints. The complex was lit by electric chandeliers and had an extensive ventilation system and plumbing. (AC.)

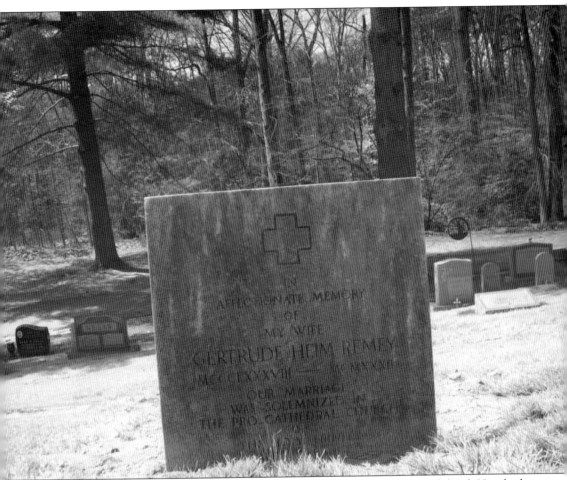

Unguarded in what was then rural Virginia, the Remeum was frequently vandalized. Hundreds of vandals defaced the complex over the years. Fragments of smashed marble reliefs and statues littered the floors. Discarded beer cans and whiskey bottles were mixed with broken funeral urns and the ashes of the dead. Statues too large to steal were chipped or painted. With construction halted, Remey relinquished all rights to the Pohick Church in 1968. Remey was given five years to remove anything of value from the mausoleum. Remey's brother-in-law, a Navy admiral, transferred the remains of 15 family members to Pompey, New York. Remey's wife, Gertrude, was reinterred in the Pohick Church Cemetery. The marker over her grave appears to be a marble plaque from the Remeum. The complex was dismantled over a period of 10 years and finally bulldozed over in 1983. (AC.)

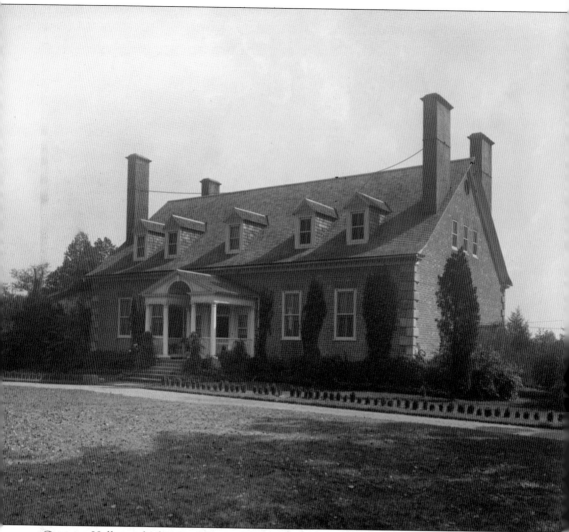

Gunston Hall was the home of George Mason IV (1725–1792), a leading figure in the American Revolution and author of the Virginia Declaration of Rights, upon which the Bill of Rights was patterned. Mason was among the first to call for such fundamental American liberties as religious toleration and freedom of the press. Mason was suspicious of a political class that had too much power and not enough checks. In May 1776, he wrote, "That the legislative and executive Powers of the State should be separate and distinct from the judicative; and that the Members of the two first may be restrained from Oppression, by feeling and participating the Burdens they may lay upon the People; they should, at fixed Periods be reduced to a private Station, and returned, by frequent, certain and regular Elections, into that Body from which they were taken." (LOC.)

In 1792, Thomas Jefferson was at the deathbed of George Mason at Gunston Hall. Mason, his first wife, Anne, and many Mason descendants are buried in the family cemetery. There are as many unmarked graves outside of the walls as there are marked graves inside of them. (LOC.)

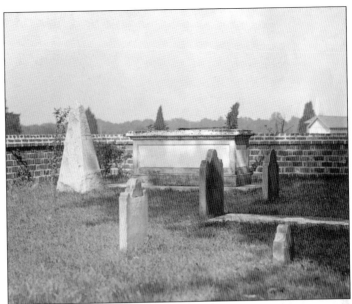

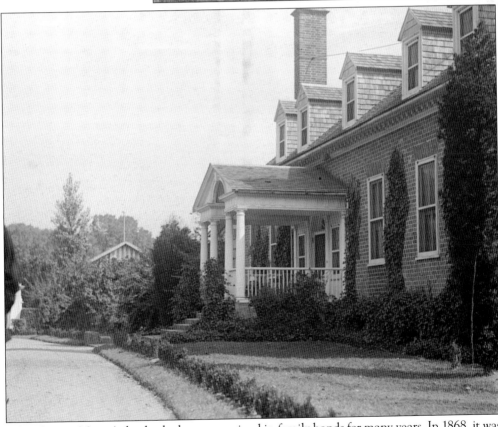

After George Mason's death, the house remained in family hands for many years. In 1868, it was purchased by noted abolitionist Edward Daniels from Mason's descendants. Daniels built a school for freedmen on the property and experimented with various scientific farming schemes during the time he owned the property (1868–1891). (LOC.)

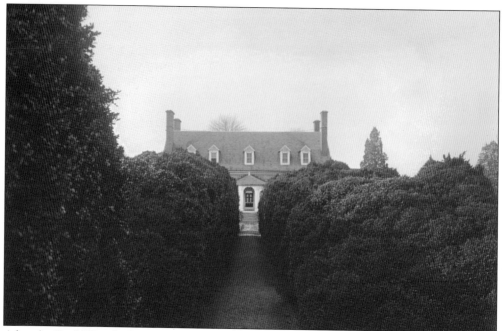

After the Civil War, the house fell into disrepair. Real restoration work was not undertaken until 1912, when Louis Hertle purchased the property. Gradually, both house and gardens returned to their former glory, becoming a gathering place for diplomats, statesmen, and leaders in business, finance, and the arts in the 1920s. (LOC.)

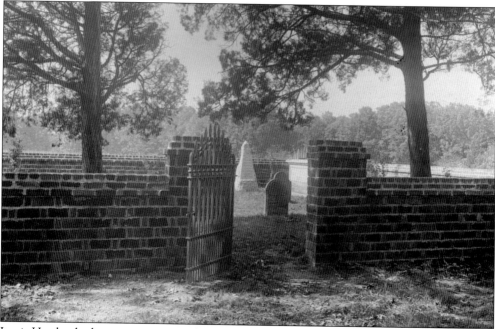

Louis Hertle, the last private owner of Gunston Hall, who found the Mason family cemetery in very poor condition, planted an avenue of cedars and laid out a path from the main yard to the cemetery in the early 1920s. Hertle erected a low brick wall around the gravestones and repaired grave markers. (LOC.)

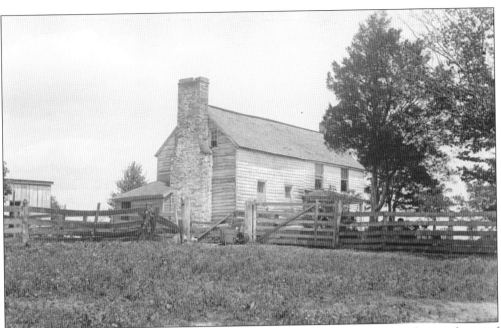

For most of its history, life in Fairfax County revolved around the farm. Today, the population of Fairfax County exceeds one million and is greater than that of such states as Wyoming. Northern Virginia did not begin to urbanize until the 1950s. In Fairfax County, most graves were located on family farms or in churchyards. (LOC.)

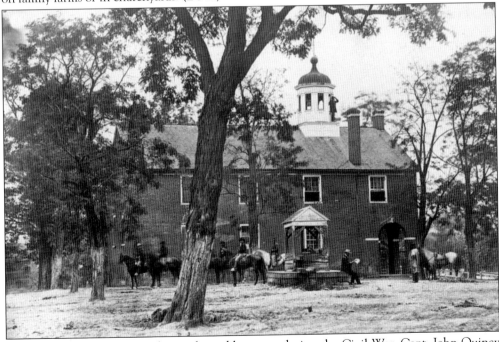

Fairfax City was the scene of several notable events during the Civil War. Capt. John Quincy Marr, the first officer casualty of the Confederacy, was killed at Fairfax Courthouse on June 1, 1861. In March 1863, Union general Edwin H. Stoughton was captured in his bed by Confederate raider Col. John Singleton Mosby. (LOC.)

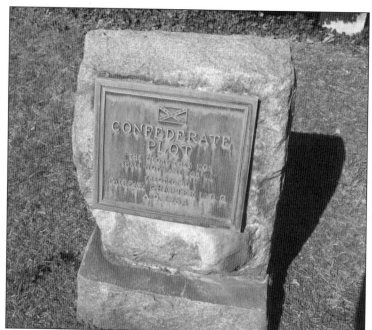

In 1866, the trustees of the Ladies Memorial Association canvassed the county and eventually some 200 unknown Confederate soldiers were reburied in a common grave atop the hill in the Fairfax City Cemetery. In 1875, ownership of the cemetery was conveyed to the trustees of the newly chartered Fairfax Cemetery Association. (AC.)

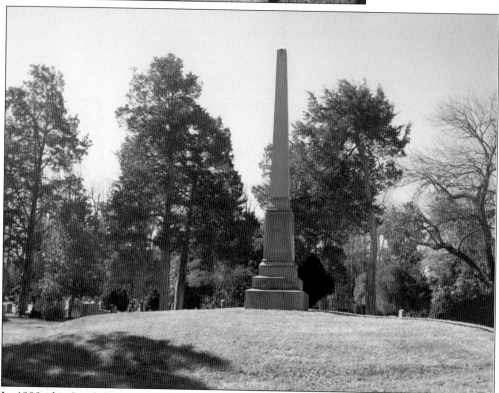

In 1888, the Confederate Monument Association was formed to erect a suitable monument to both the unknown Confederate dead buried in the cemetery and the Confederate soldiers from Fairfax who lay on battlefields far from home. In October 1890, the monument was officially dedicated. Control of the cemetery passed to the City of Fairfax in 1962. (AC.)

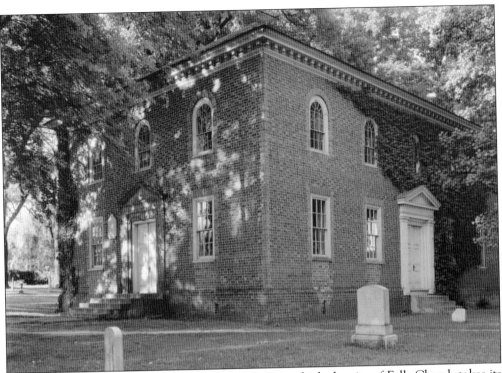

The Falls Church is a historic Episcopal church from which the city of Falls Church takes its name. The parish was established in 1732, and the brick meetinghouse preserved on-site dates to 1769. The 1769 structure is the oldest remaining church building in Northern Virginia. Early burials can be found in the churchyard. (LOC.)

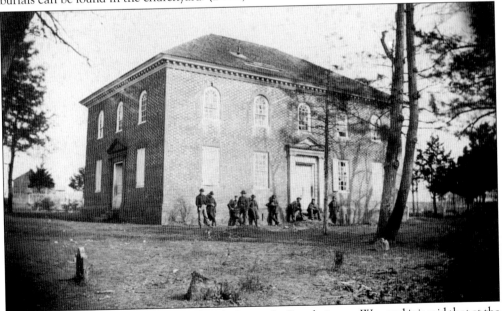

The Fairfax militia recruited from the church during the Revolutionary War, and it is said that at the war's end, the Declaration of Independence was read to citizens from the steps of the south doors. During the Civil War, the church was variously used as a Union hospital and stable. (LOC.)

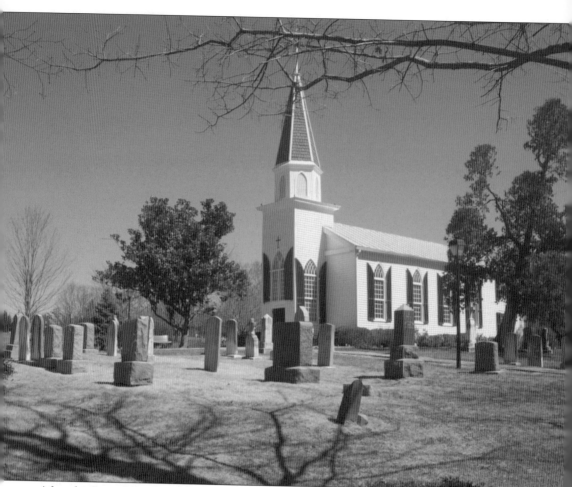

After the Second Battle of Manassas in August 1862, Clara Barton, a clerk at the Government Patent Office who had gathered a group of volunteers, nursed the wounded for three days at St. Mary's Church near Fairfax Station. Many soldiers died and were buried in the churchyard. As a result of her experiences in the Civil War, Barton went on to establish the American Red Cross. She began this project in 1873 but was initially told that since the United States would never again face a crisis like the Civil War such an organization was unnecessary. Barton finally succeeded in convincing critics by using the argument that the new the American Red Cross could respond to crises other than war such as earthquakes, forest fires, and hurricanes. Barton became president of the American Red Cross in May 1881. (AC.)

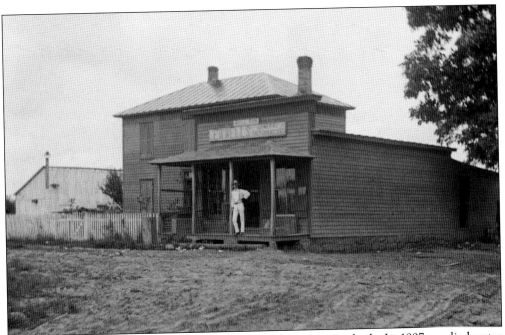

Civil War burials are still being found as new developments are built. In 1997, a relic hunter stumbled on a burial near 5900 Centreville Road and contacted county archaeologists. Six soldiers were buried at the site. Because they were buried in coffins and not in a mass grave, archaeologists believe that the soldiers died of disease. (LOC.)

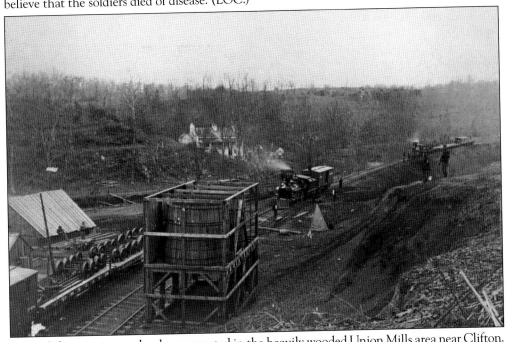

A Confederate cemetery has been reported in the heavily wooded Union Mills area near Clifton. The site is said to be on the north side of the Southern Railway tracks. During the first year of the war, the Confederates made the Union Mills area part of the defense line that ran from Centreville to Manassas Junction. (LOC.)

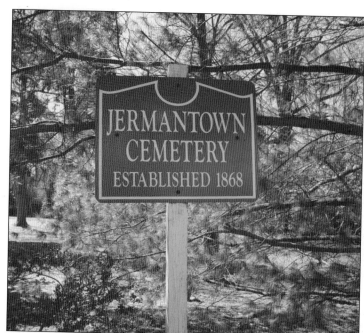

The Jermantown Cemetery was established in 1868 for African American residents who could not be buried in the segregated Fairfax City Cemetery. There are over 40 headstones and an undetermined number of unmarked graves. Since there are no more trustees to care for the cemetery, Fairfax City has maintained the mowing of the site. (AC.)

Notable among those buried in the Jermantown Cemetery are George Lamb, a free African American who served in the Confederate army as a body servant to Capt. William H. Dulaney of the Fairfax Rifles, and Horace Gibson, a freed slave who later owned his own blacksmith shop in Annandale. (AC.)

At the intersection of Lorton Road (Local Route 642) and Ox Road (Virginia Route 123), a history marker notes, "In the nearby Occoquan Workhouse, from June to December, 1917, scores of women suffragists were imprisoned by the District of Columbia for picketing the White House demanding their right to vote. Their courage and dedication during harsh treatment aroused the nation to hasten the passage and ratification of the 19th Amendment in 1920. The struggle for woman's suffrage had taken 72 years." Lorton Prison, also known as the District of Columbia Correctional Facility, was opened in 1910 as the Occoquan Workhouse. In 1917, the Occoquan Workhouse housed as many as 100 women suffragettes (one of whom, Lucy Burns, is seen here) arrested while picketing the White House. Lorton Prison was officially closed in 2002. The prison's graveyard was known as Stoney Lonesome. (LOC.)

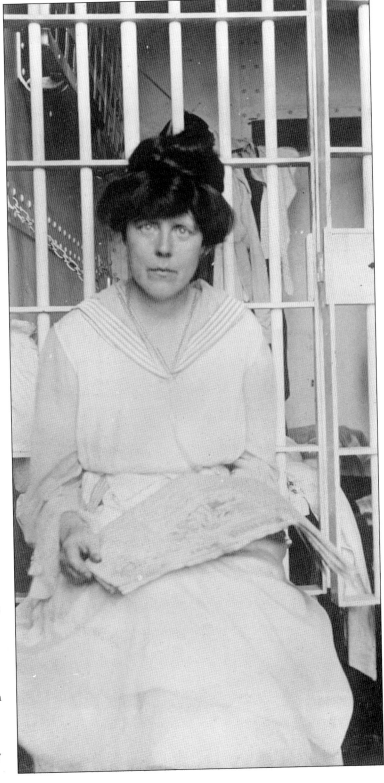

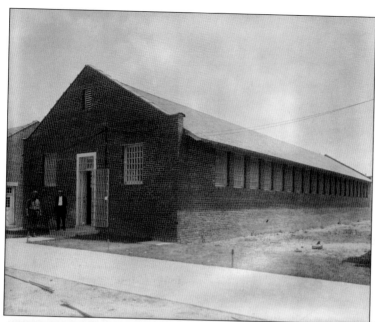

Stoney Lonesome Cemetery was a sort of potter's field that dates back to just after the Occoquan Workhouse (pictured) was established in 1910. A small plot of land was set aside to bury those who died while incarcerated and who had no friends or family to take care of the burial. (LOC.)

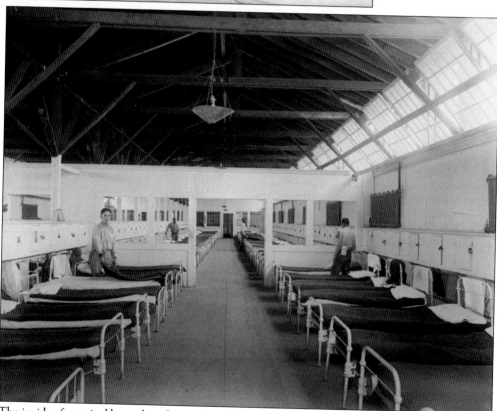

The inside of a typical barrack at the workhouse is seen here. A pine box fashioned in the carpenter shop at the workhouse served as a coffin. Graves were hand-dug by a lone inmate. Located in a grove of cedar trees, the graves are laid out in north-south rows and are now just depressions in the ground. (LOC.)

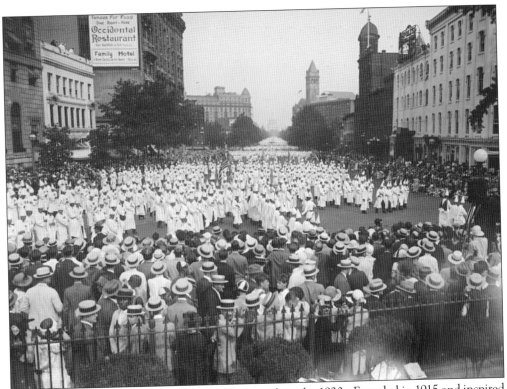

The influence of the Ku Klux Klan reached its zenith in the 1920s. Founded in 1915 and inspired by the Reconstruction-era organization of the same name, the second Ku Klux Klan was avowedly racist, anti-Catholic, and anti-Semitic. In this photograph, 40,000 members of the Klan march down Pennsylvania Avenue on August 8, 1925. (LOC.)

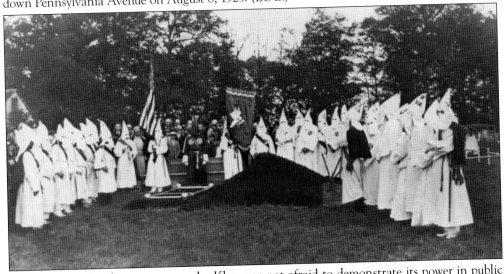

Although membership was secret, the Klan was not afraid to demonstrate its power in public displays. This photograph shows the Klan attending a funeral at a Fairfax County cemetery in 1929. Although it enjoyed strong support in the South, the Klan was strongest in the Midwest and Southwest, boasting an estimated three million members at its height. (Fairfax County Public Library.)

Congress passed the Washington Airport Act in 1950, which provided funding for a second, larger airport to serve the capital region. Willard, a largely rural black community, was selected as the site of the new airport. Willard's 87 area landowners received condemnation letters early in September 1958. In all, 9,800 acres were condemned, with the government paying some $500 an acre. Some 300 buildings were leveled to make way for the new Dulles Airport, named after President Eisenhower's secretary of state John Foster Dulles, an aviation enthusiast. When Washington Dulles International Airport was planned in the mid-1950s, an issue arose regarding the disposition of the cemeteries located in the area designated for the new airport. Four cemeteries were moved from the Dulles area in the late 1950s and other burials in 1996, when the airport extended a runway. (LOC.)

64

Three

ALEXANDRIA

The first native inhabitants arrived around Alexandria some 13,200 years ago, establishing fishing camps along the Potomac River.

Scottish merchants established the first permanent settlement in 1749, and Alexandria became a prosperous trading center. In 1755, Alexandria became a staging area for British troops during the French and Indian War. English general Edward Braddock made his headquarters at the house of John Carlyle, a prominent citizen, while planning his ill-fated campaign against the French.

In Colonial times, Alexandria became one of the 10 busiest ports in America. George Washington shipped wheat and fish through Alexandria merchants, maintained a townhouse there, and served as a trustee of Alexandria. Washington also purchased a pew in Christ Church.

In 1789, Alexandria and a portion of Fairfax County were ceded by the State of Virginia to become a part of the new District of Columbia. Alexandria was retroceded to Virginia in 1847.

Henry "Light-Horse Harry" Lee, a Revolutionary War general, and the father of Robert E. Lee, brought his family to Alexandria in 1810. Robert E. Lee lived in Alexandria until his departure for West Point in June 1825.

Before the Civil War, Alexandria became a center for the domestic slave trade. Thousands of slaves from Virginia were transported from Alexandria to Alabama, Louisiana, Mississippi, and other Deep South states hungry for labor to work on cotton plantations.

Within days of Virginia's secession from the Union in the spring of 1861, Federal troops occupied Alexandria, which became an important logistical center for the Union army. During the Civil War, African American refugees flooded into Union-controlled areas, including Alexandria. Many of these former slaves served as soldiers in the Union army, while others found work supporting the army.

In modern times, Alexandria has made a serious and concerted effort to preserve its history. The Old and Historic District, designated in 1946, was the third historic district established in the United States, after Charleston and New Orleans.

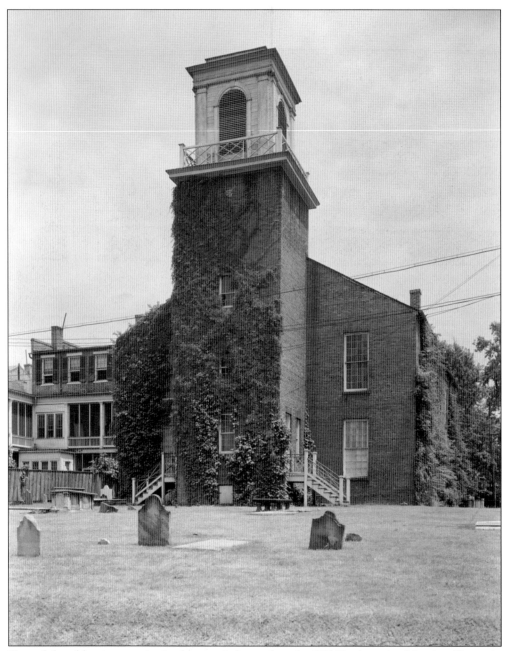

One of the oldest cemeteries in the area is located at the Old Presbyterian Meeting House in Alexandria. Most of the graves here date to the 18th century. The most unusual grave here is the Tomb of the Unknown Revolutionary War Soldier. An inscription placed on the table tomb at the dedication of the memorial reads, "Here lies a soldier of the Revolution whose identity is known but to God. His was an idealism that recognized a Supreme Being, that planted religious liberty on our shores, that overthrew despotism, that established a people's government, that wrote a Constitution setting metes and bounds of delegated authority, that fixed a standard of value upon men above gold and lifted high the torch of civil liberty along the pathway of mankind. In ourselves this soul exists as part of ours, his memory's mansion." (LOC.)

In 1826, workers digging a foundation behind the Old Presbyterian Meeting House found an unmarked grave. The tattered uniform of the grave's occupant identified the man as a Revolutionary War soldier from Kentucky. The soldier's remains were reinterred in the cemetery behind the meetinghouse. In 1929, a memorial was created. (LOC.)

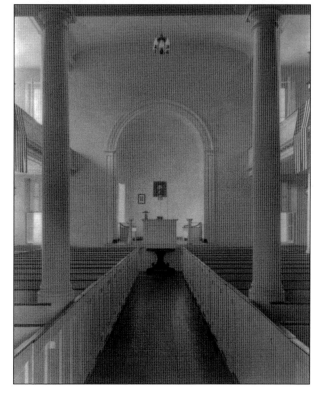

The tomb of the Unknown Revolutionary War Soldier has fallen into obscurity. The Old Presbyterian Meeting House (interior view seen here), which cares for the unknown soldier's grave, reports that only five or six people a day pick up the pamphlet explaining what it is. A wreath is laid at the tomb on Presidents Day. (LOC.)

The grave of John Carlyle (1720–1780) is located at the Old Presbyterian Meeting House. Carlyle, a personal friend of George Washington, was born in Scotland in 1720. He came to Virginia as the agent of a merchant at the age of 21 in hopes of, in his words, making "a fortune sufficient . . . to live independent." He achieved success within seven years. Carlyle's extensive business activities included import and export trade to England and the West Indies, retail trade in Alexandria, an iron foundry in the Shenandoah Valley, milling, and a blacksmithing operation. Carlyle bought thousands of acres of land and operated three working plantations. In 1749, Carlyle became one of the founding fathers of Alexandria. In 1774, the Fairfax County Committee of Safety was organized. Carlyle became a member. Risking everything, Carlyle warmly supported the Revolution, but he died before final victory was achieved. (LOC.)

In 1753, John Carlyle built a grand home in Alexandria. The house was used by British general Edward Braddock in 1755 as his headquarters while planning an ill-fated campaign against the French in Pennsylvania. The house fell into disrepair over the centuries and was saved from demolition by dedicated preservationists. (LOC.)

This was the Carlyle House before restoration. John Carlyle's life was marred by personal tragedy. Of his 11 children, only two lived to adulthood. His first wife, Sarah, bore seven children. Five died in childhood, and Sarah died in childbirth. Carlyle's second wife, Sybil, bore four children, none of whom lived to adulthood. (LOC.)

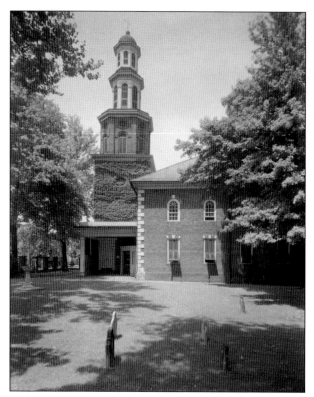

The oldest legible tombstone surviving in Alexandria is that of Isaac Pierce, erected in 1771 in the Christ Church graveyard. All earlier grave markers have disappeared or become illegible over the years. The historic core of Alexandria now contains 15 historic cemeteries. At least 20 additional burial locations have been identified in the historic district. (LOC.)

In 1804, the Alexandria Common Council prohibited new cemeteries within the existing boundaries of Alexandria. Christ Church and other local churches settled on an area known as Spring Garden Farm as the site for future burials. The area is now known as the Wilkes Street Cemetery Complex, which includes 13 cemeteries. (LOC.)

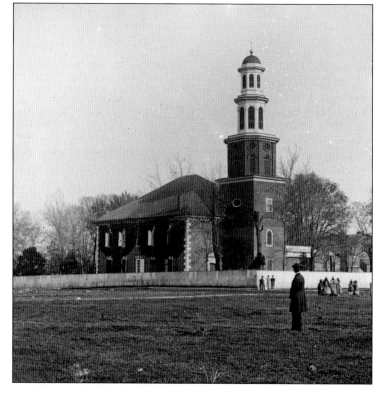

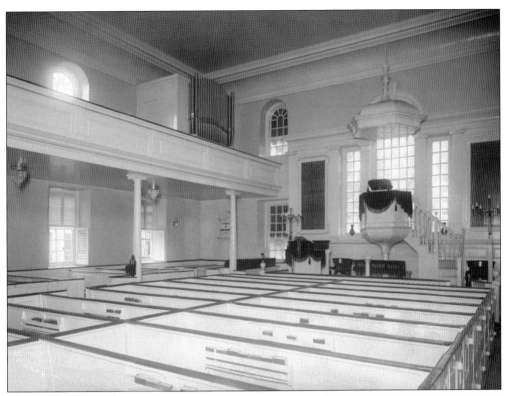

Christ Church was the church of George Washington. The Washington family pew is preserved inside. The present building dates from 1771 to 1773, although vestry records show burials in the churchyard as early as 1766. Parts of the churchyard have been filled in while other parts have been leveled off over the years. (LOC.)

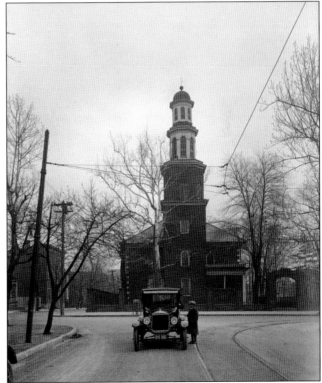

There are many more graves than headstones in the Christ Church graveyard. At least 396 unmarked graves date from 1787 to 1796, with 174 of them being the graves of children. An estimated 540 additional unmarked graves are attributed to years for which burial records are missing. (LOC.)

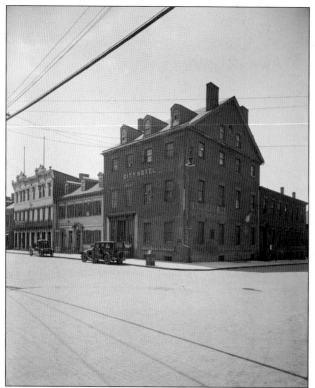

Perhaps the most romantic tombstone in Virginia is that of Alexandria's "Female Stranger." In September 1816, a young couple arrived in Alexandria. The lady was very ill. She remained in her room at a local inn (Gadsby's Tavern, pictured) until her death. The identity of the Female Stranger remains a mystery that has lingered beyond the grave. (LOC.)

The ghost of the Female Stranger is said to haunt the room in which she died. What secret did the young couple hide? Were they eloping? Was she an English aristocrat, royalty, the daughter of a prominent politician? Gadsby's Tavern is still in operation, and visitors can see the room in which the Female Stranger died. (LOC.)

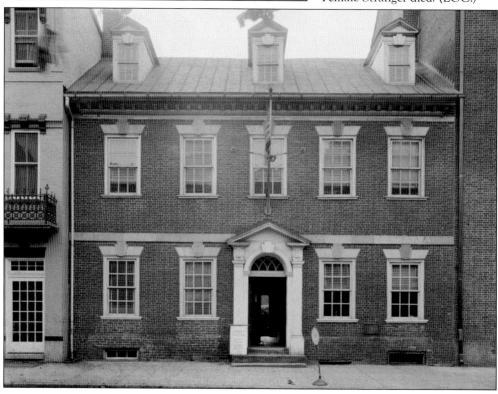

After her death, the young lady's husband erected a tomb in nearby St. Paul's Episcopal Church Cemetery, now part of the Wilkes Street Cemetery Complex, a cluster of historic graveyards. Her tombstone reads, "To the Memory of a FEMALE STRANGER whose mortal sufferings terminated on the 14th day of October 1816 Aged 23 years and 8 months. This stone is placed here by her disconsolate Husband in whose arms she sighed out her latest breath and who under God did his utmost even to soothe the cold dead ear of death. How loved how valued once avails thee not. To whom related or by whom begot, A heap of dust alone remains of thee. Tis all thou art and all the proud shall be. To him gave all the Prophets witness that through his name whosoever believeth in him shall receive remission of sins. Acts.10th Chap.43rd verse." (AC.)

A tall stone obelisk was erected on the grounds of Ivy Hill Cemetery in 1855 as a memorial to seven city firefighters who had died while fighting a massive blaze. The cemetery itself was established in 1856 and now covers 25 sloping acres off of King Street, west of the George Washington Masonic National Memorial. (AC.)

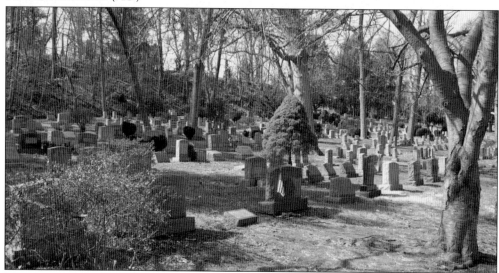

The thousands of headstones at Ivy Hill are a portal to the city's rich past. Here lie descendants of Thomas Jefferson, Union and Confederate soldiers, members of some of the city's oldest families, and the rocket scientist Wernher von Braun, regarded as the father of the US space program. (AC.)

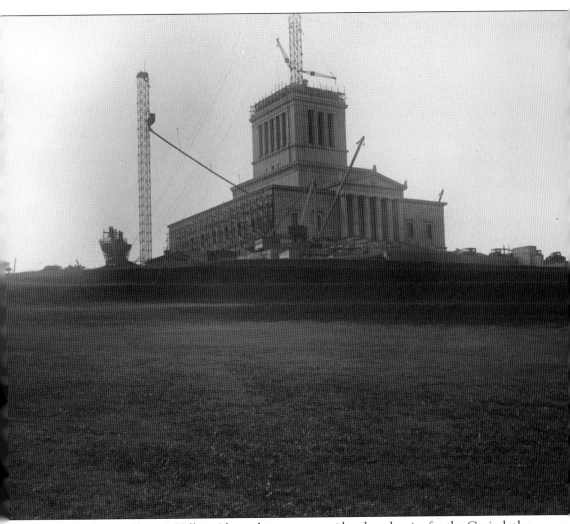

Sitting high atop Shuter's Hill in Alexandria, once considered as the site for the Capitol, the Alexandria-Washington Freemason Lodge No. 22 dominates the local skyline, as well it might, being the lodge of none other than Worshipful Brother George Washington. In Masonic terms, Washington was, "a just and upright Mason," a "living stone" who became the cornerstone of American civilization. He presided over the cornerstone ceremony for the Capitol in 1793, laying the cornerstone in Masonic garb, as chronicled by the *Alexandria Gazette* of September 25, 1793. A family cemetery was located to the right of the George Washington National Masonic Shrine (seen here under construction). In early America, small family cemeteries were common. In 1755, a Mrs. Brown, an English visitor to Colonial Alexandria, noted, "It is the custom of this place to bury their relatives in their gardens." (LOC.)

A Quaker burying ground was established on Queen Street in 1784 on land now partially used by the public library named after Kate Waller Barrett (seen here). This cemetery was excavated by Alexandria Archaeology in 1993 before a library expansion. Dr. Elisha Cullen Dick, George Washington's physician was buried in this cemetery. (LOC.)

Home of Peace Cemetery, used by Beth El Hebrew Congregation, is located at the Wilkes Street Cemetery Complex. Home of Peace is the earliest Jewish cemetery in Alexandria. A Hebrew Benevolent Society was established in 1857 to provide a burying ground for Alexandria's Jewish community, which had been increasing since the 1830s. (AC.)

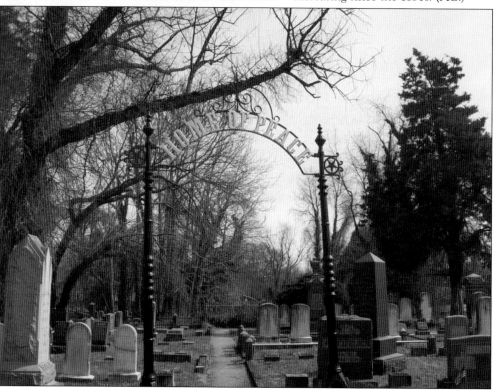

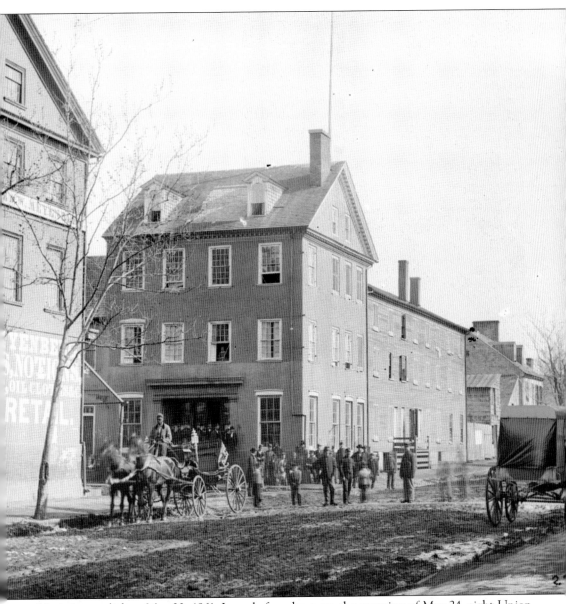

Virginia seceded on May 23, 1861. Long before dawn on the morning of May 24, eight Union regiments crossed the Potomac River to seize Alexandria. Union troops entered Alexandria unopposed. Col. Elmer Ellsworth led his men down the empty streets until he came to the Marshall House, a hotel flying the Confederate flag. Ellsworth, followed by his soldiers, went inside, hurried to the roof and, with a knife borrowed from a private soldier, cut down the emblem of rebellion. Ellsworth started back for the street with the flag tucked under his arm. In a shadowy hallway, he met the proprietor of the inn, James Jackson. Jackson produced a shotgun and killed Ellsworth. Within seconds, he was cut down by one of Ellsworth's soldiers. War had come to Virginia. The peaceful farmlands of Virginia would be red with blood before peace finally came again. (LOC.)

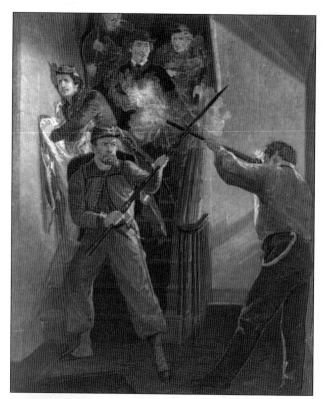

According to a friend, ardent secessionist James W. Jackson had "obstinate determination . . . stamped on every feature." A coroner's jury at Alexandria found that Jackson "came to his death at the hands of troops of the United States while in the defense of his private property, in his own house." (LOC.)

Ellsworth, a personal friend of President Lincoln, lay in state at the White House before being sent to New York for burial. James Jackson was initially buried in the Jackson Family Cemetery in Fairfax County. He was later reburied next to his wife, Susan, and other family members in the Fairfax City Cemetery. (AC.)

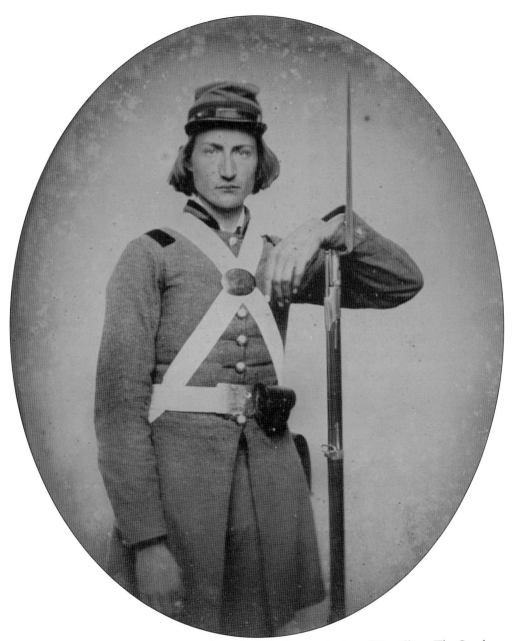

At the beginning of the war, the Northern states had a population of 22 million. The Southern states had a population of about nine million (including 3.5 million slaves). The Union forces outnumbered the Confederates roughly two to one. The Union fielded some two million soldiers, the Confederacy some one million soldiers (a typical soldier from Virginia is seen here). Everyone expected the war to be over quickly. It was the tremendous and growing rush of cotton wealth that made the South's pride both brittle and aggressive. The South's explosion of wealth depended on cotton, and the economical production of cotton demanded slavery. A prime field hand could bring as much as $1,500, and his value compounded every time he reproduced. Any Northern move that threatened either cotton or slavery was like a dagger pointed at the heart of the South. (LOC.)

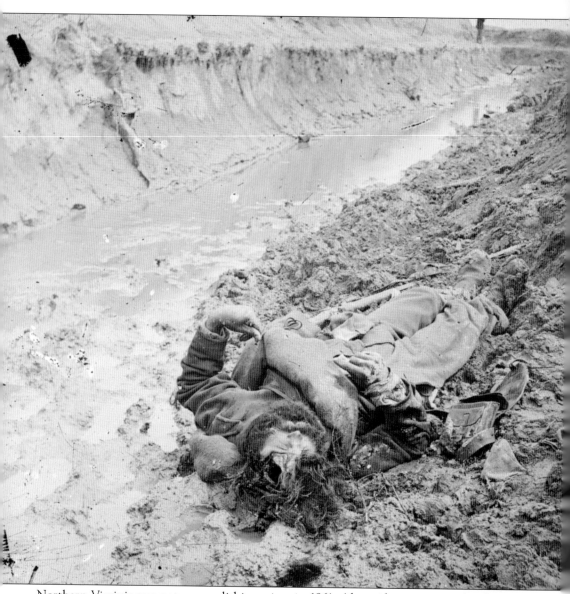

Northern Virginia was not a monolithic society in 1861. Alongside aristocratic families were merchants and small farmers, poor whites, free blacks, slaves, Quakers, and hundreds of enterprising and ambitious Northerners. During the first few years of the war, many parts of Northern Virginia became a no-man's-land in which Union and Confederate troops and sympathizers spasmodically and violently struggled for control. In June 1861, both sides sent scouting parties into the countryside. The first major battle of the war was fought at Manassas on Sunday July 21, 1861. The Civil War dragged on four long years, becoming the bloodiest war in American history. Some 600,000 people, combatants and noncombatants, died. As a percentage of the population, this would be equivalent to five million deaths in present-day America. Many soldiers were buried where they fell. In an era before identification tags, thousands of soldiers went to unknown graves. (LOC.)

Esther Alden expressed the attitude of many young women in the South as the war progressed, "One looks at a man so differently when you think he may be killed tomorrow. Men whom up to this time I had thought dull and commonplace . . . seemed charming." The famous diarist Mary Chestnut of South Carolina was appalled when she saw women of her own class flirting openly with strangers in public. The diaries of hundreds of women of the time attest to the "marrying craze" sweeping the South. "Every girl in Richmond is engaged or about to be," wrote Phoebe Pember Yates in February 1864. Fear of spinsterhood and natural desire heightened by the immediacy of war led to many unconventional matches, many reflecting the truth of a phrase common to the time, "The blockade don't keep out babies." The war left many young widows with small children to raise. (LOC.)

Julia Wheelock came to Alexandria searching for her brother, and after learning of his death, she stayed to nurse the wounded. She wrote, "We all went out to Fairfax Seminary Hospital . . . This is a large hospital and will accommodate several hundred patients. It is situated in a delightful place . . . commanding a fine view of the country for miles around. It was formerly a theological seminary." Patients universally praised the facility, known as the best hospital in Alexandria. Supt. Jane S. Woolsey ran a crisp and efficient organization, which also provided comfort. The well-equipped kitchen prepared dishes for patients on special diets. The seminary housed 1,700 wounded Union troops. Despite the hospital's best efforts, many died; 500 soldiers were buried on the grounds. The seminary was founded in 1823, and a formal cemetery was established on the grounds in 1876. (LOC.)

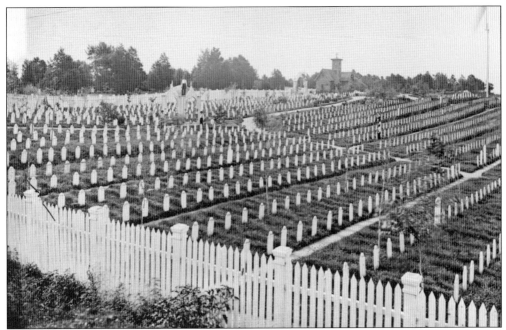

First known as the Soldier's Cemetery, Alexandria National Cemetery was one of the first national cemeteries established, in 1862, in accordance with a Congressional mandate. There are 3,533 Civil War veterans buried here. Originally, 39 Confederate soldiers were interred here, but most were moved to Christ Church Cemetery in 1879. (LOC.)

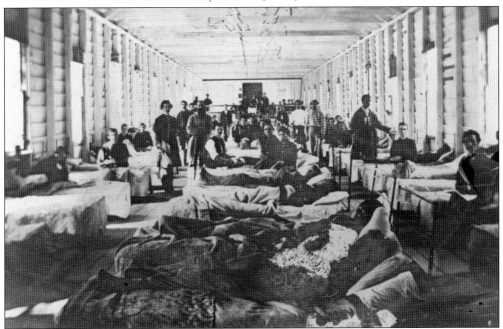

Alexandria National Cemetery is one of the original 14 national cemeteries established in 1862. The first burials were soldiers who died during training or from disease in the numerous overcrowded hospitals around Alexandria (the ward of a typical Union hospital is seen here). By 1864, the cemetery was nearly filled to capacity. (LOC.)

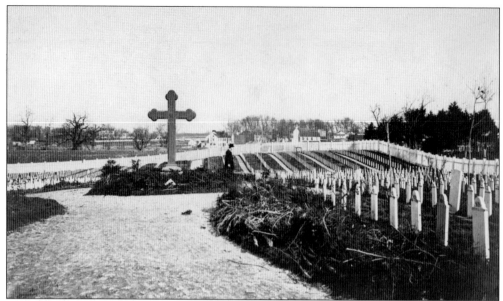

"We had gone but a few steps when . . . we saw a soldier's funeral procession approaching, a scene I had never witnessed, but one with which I was destined to become familiar . . . He is escorted to his final resting place . . . by comrades . . . with unfixed bayonets, and arms reversed, keeping time with their slow tread and solemn notes of the 'Dead March,'" wrote Julia Wheelock. (LOC.)

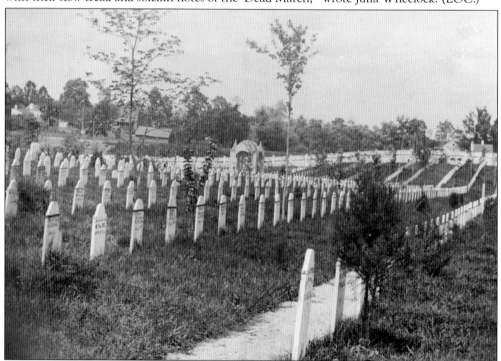

On June 17, 1863, Pvt. Lewis Bissell recorded a funeral procession en route to Soldier's Cemetery. "The ambulances, seventeen in number, each with two coffins, were followed by officers and men. They marched to mournful music played by the First Connecticut Artillery band . . . It was a sad sight to see the procession move towards the soldier's graveyard in Alexandria." (LOC.)

Nathaniel Shoup of Company C, 84th Pennsylvania Infantry Regiment is seen here in uniform. Shoup was born 1842, enlisted on October 1, 1861, and died of typhoid fever in Alexandria on June 29, 1862. He is buried at the Alexandria National Cemetery, Gravesite No. 59. His gravestone reads "Nath'l Shoup, Sgt. Pa." (LOC.)

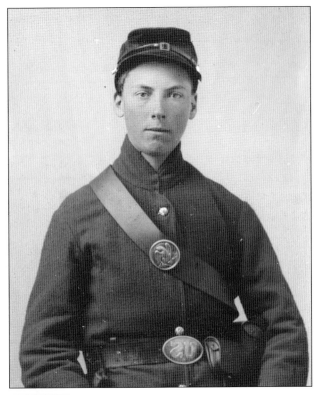

Before the ambrotype photograph of Nathaniel Shoup was donated to the Library of Congress, Christian Liljenquist (seen here with the photograph of Shoup) went to Shoup's gravesite at Alexandria National Cemetery. Shoup's regiment lost 224 men during the war; 125 died as a result of battle, while 99 died of disease. (LOC.)

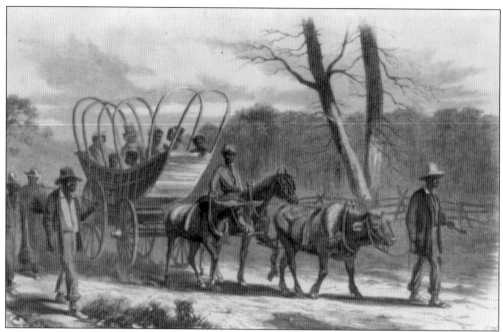

Depicted here is contraband coming into the Union lines. In April 1862, President Lincoln emancipated all slaves in the District of Columbia and nine months later issued the Emancipation Proclamation. Many blacks from nearby states sought refuge in Alexandria. Those who came under Union control were known as "contraband of war." (LOC.)

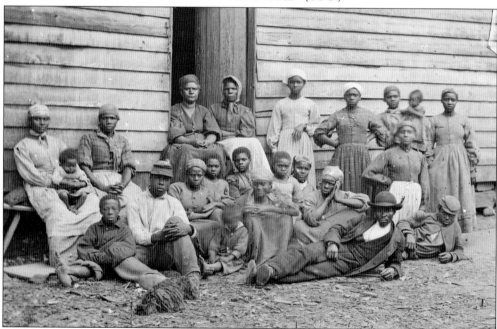

Thousands of freed slaves looked for safety around Alexandria. Often, they found horrible living conditions, sickness, disease, and death. In 1865, the military governor of Alexandria seized the pasture of a Confederate sympathizer and established a burying ground for the freedmen. Some 1,700 freed people were buried here. (LOC.)

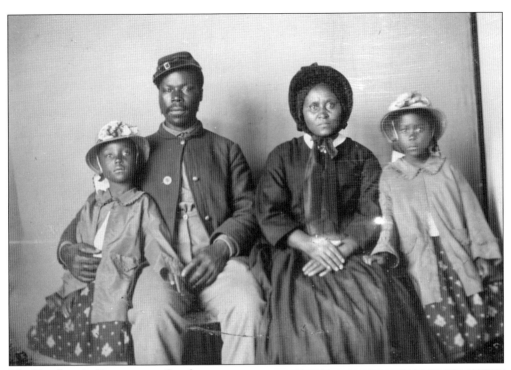

The Freedmen's Cemetery on South Washington Street in Alexandria was created during the Civil War as a burial place for former slaves fleeing the Confederacy and flocking to Alexandria. African American soldiers fighting in the Union army were also buried here, but these soldiers were reburied at the newly created Alexandria National Cemetery. According to the Library of Congress, this image was found in Cecil County, Maryland, and the unidentified soldier, pictured with his wife and daughters, probably belonged to one of the United States Colored Troops regiments raised in Maryland. (LOC.)

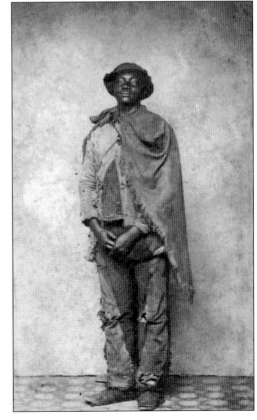

Over time, the wooden markers memorializing the dead at the Freedmen's Cemetery decomposed. In the 1930s, the George Washington Memorial Parkway was built over part of the graveyard. Construction of the Beltway destroyed the southern edge of the cemetery. In 1955, a gas station was built on top of the graves. This photograph dates from the Civil War era. (LOC.)

The cemetery was rediscovered by archaeologists and historical researchers in the activity surrounding the expansion of the Woodrow Wilson Bridge and purchased by the City of Alexandria in 2007. On May 12, 2007, the site was rededicated as the Freedmen's Memorial Park. Alexandria Archaeology identified locations of more than 500 of the 1,800 graves once located in the cemetery. No grave could be associated with a particular person. A wooden picket fence once surrounded the cemetery. The Army Quartermaster Corps supplied wooden headboards at the time of the burial. Each headboard was whitewashed and had the name of the deceased written in black lettering. Several graves had stone markers, supplied by the families. A fragment of one stone marker was found during excavation. The graves were placed very close to one another in orderly rows. Gravediggers were probably unaware that they were digging into an important Native American site. A 13,000-year-old spear point was recovered here in 2007. (AC.)

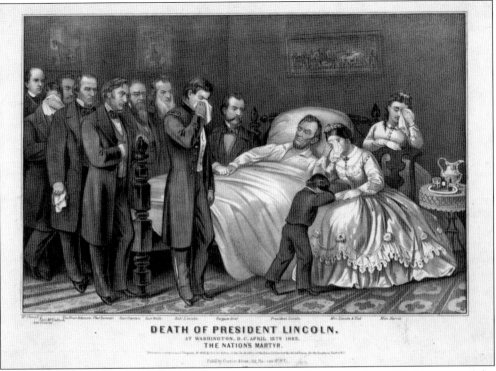

DEATH OF PRESIDENT LINCOLN.
AT WASHINGTON, D.C. APRIL 15TH 1865.
THE NATION'S MARTYR.

"The whole community was startled this morning, early, by reports from Washington, of the murder of the President of the United States, and the attempted assassination of the Secretary of the State and his son. So astounding was the intelligence, the rumor was at first discredited. No one believed that such a tragedy did or could happen," reported the *Alexandria Gazette*. (LOC.)

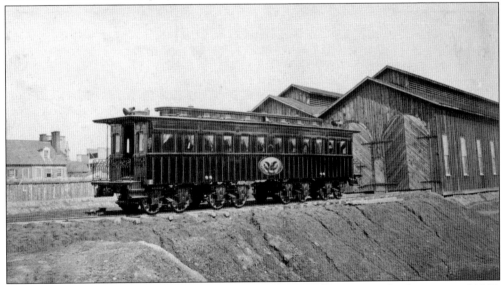

During the Civil War, Alexandria became an important railway center. In the spring of 1865, a private railroad car was constructed in Alexandria for President Lincoln's personal use. Sadly, this special presidential car was employed for the first time as a funeral car to transport the slain Lincoln to his home in Springfield, Illinois. (LOC.)

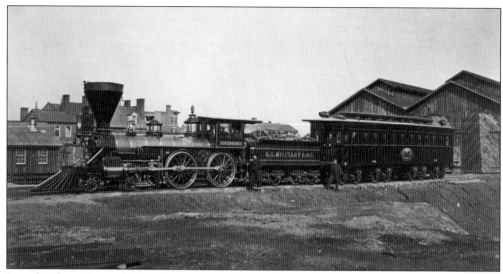

Lincoln's funeral train left Washington on April 21, 1865, and retraced much of the route Lincoln had traveled as president-elect in 1861. The nine-car Lincoln Special, whose engine displayed Lincoln's photograph over the cowcatcher, carried approximately 300 mourners. Depending on conditions, the train usually traveled between five and 20 miles per hour (LOC.)

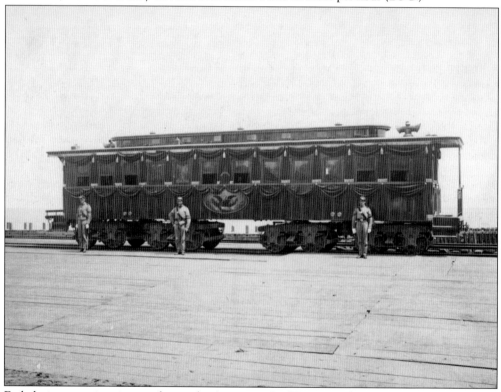

Embalming came into its own during the American Civil War. President Lincoln was assassinated on April 14, 1865, but his body was not interred in Springfield, Illinois, until May 4. The passage of the body home for burial was made possible by embalming and brought the possibilities of embalming to the attention of a wider public. (LOC.)

Four

ARLINGTON
NATIONAL CEMETERY

Arlington National Cemetery was created as a military cemetery during the Civil War to accommodate Union dead. Pvt. William Henry Christman from Pennsylvania was the first soldier to be buried at Arlington. A laborer, Christman enlisted in the Federal army on March 25, 1864. He was hospitalized for measles five weeks later and died on May 11. He was buried on May 13, 1864. By the end of the Civil War, there were some 16,000 burials at Arlington.

Today, the cemetery encompasses 624 acres and is divided into 70 sections, including the Confederate section, the section for those who died in the Global War on Terrorism, and the nurses' section. Some 3,800 freed slaves, called contrabands during the Civil War, are buried in Section 27. Their graves are marked "Citizen." The remains of more than 400,000 people from the United States and 11 other countries are buried at Arlington, including some 400 Medal of Honor recipients. Four million people visit the cemetery annually.

There 28 major and 142 minor monuments and memorials within the cemetery's grounds. The first major memorial was completed in 1866. Entry gates to the cemetery were later dedicated to Union army generals. The Spanish-American War and World War I spurred the construction of several major memorials. The Tomb of the Unknown Soldier was constructed in 1921, and the iconic sarcophagus above the burial was dedicated in 1932. Almost a third of the cemetery's major memorials have been constructed since 1983. Arlington National Cemetery no longer permits the construction of large memorials or monuments unless they have been previously approved by an act of Congress. The cemetery does, however, encourage the donation of trees and permits small memorial plaques to be placed near the trees.

Five state funerals have been held at Arlington, including those of Pres. William Howard Taft and Pres. John F. Kennedy, as well as those of Sen. Robert F. Kennedy and Sen. Edward M. Kennedy, and General of the Armies John J. Pershing.

George Washington Parke Custis (left) inherited 1,100 acres overlooking the Potomac River, when his father, the stepson of Gen. George Washington, died. Custis had one daughter, Mary. Mary Custis fell in love with Robert E. Lee. In 1857, George Washington Parke Custis died. Mary and Robert E. Lee lived in Arlington House until 1861. (LOC.)

When Virginia seceded, Lee joined the Confederate army. Union troops moved into Virginia in May 1861 and took up positions around Arlington House. The property was confiscated when property taxes were not paid in person by Mary Custis Lee. The property was purchased by a tax commissioner for government use. (LOC.)

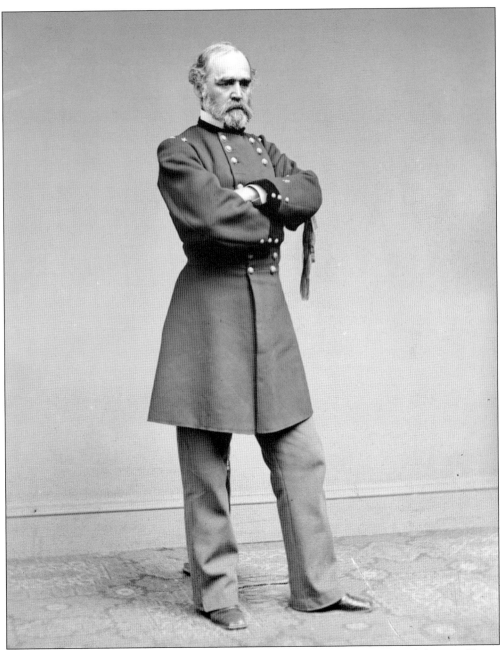

Brig. Gen. Montgomery C. Meigs (pictured), commander of the garrison at Arlington House and quartermaster general of the Union army, who may have had a grudge against Robert E. Lee, was tasked with finding additional burial grounds for battle casualties. Meigs and Lee had served together many years earlier as military engineers on the Mississippi River. Lee was a 1st lieutenant and Meigs his subordinate, a 2nd lieutenant. Did Meigs bear Lee a personal grudge? Some historians think so, or perhaps he was just embittered by the war itself, or by Lee's defection from the Union army. Meigs wrote to the secretary of war stating that "the grounds about the mansion are admirably suited to such a use." Meigs reported his "grim satisfaction" of ordering 26 Union dead to be buried near Mary Custis Lee's rose garden in June 1864. (LOC.)

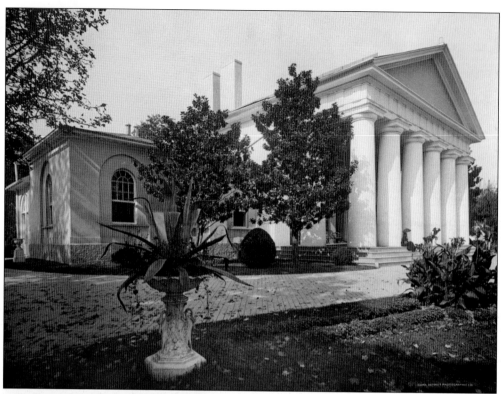

Meigs had graves dug right up to the entrance to the house. This was malicious. Meigs intended to prevent the Lee family from ever again inhabiting the house. More than 16,000 Union soldiers were buried on the estate's grounds. Meigs's own son was sent to Arlington Cemetery for burial. (LOC.)

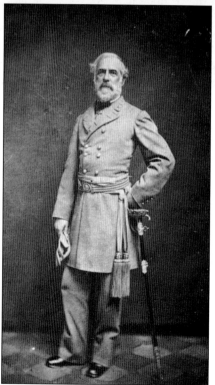

Neither Robert E. Lee (left) nor his wife ever set foot in Arlington House again. In 1882, the Supreme Court returned the property to the Lee family, stating that it had been confiscated without due process. General Lee's son sold the house and land to the government for its fair market value. (LOC.)

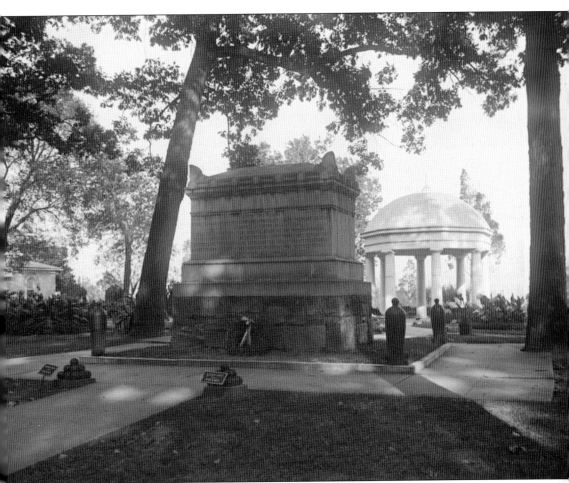

The first memorial constructed was the Civil War Unknowns Monument, which was meant as a tribute to Union soldiers. Bodies of 2,111 dead soldiers were collected within a 35-mile radius. Most were full or partial remains discovered unburied and unidentifiable. Because of the inability to identify remains, it is thought that some Confederate dead were also interred here. An inscription on the west face of the memorial describes the number of dead in the vault below. Originally, a Rodman gun was placed at each corner and a pyramid of shot adorned the center of the lid. By 1893, the memorial had been redesigned. The plain walls had been embellished, and although the inscription had been retained, the lid was replaced by one modeled after the Ark of the Covenant. The Civil War Unknowns Monument was the inspiration for Montgomery Meigs's own tomb, also located at Arlington National Cemetery. (LOC.)

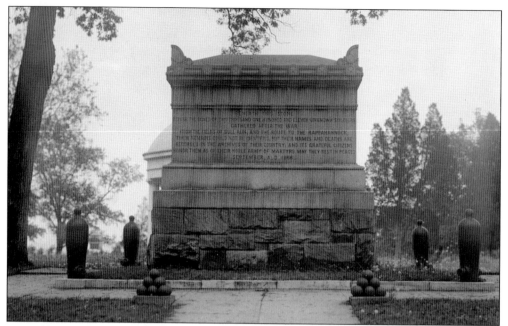

Several hundred Confederate dead were buried at Arlington by the end of the war in April 1865. Some were prisoners of war who died in custody, some were executed spies, and some were battlefield dead. The federal government did not permit the decoration of Confederate graves. (LOC.)

In 1868, families of dead Confederates were barred from the cemetery on Decoration Day (now Memorial Day). Union veterans prowled the cemetery, ensuring that Confederate graves were not honored in any way. Families of Confederates buried at Arlington were refused permission to lay flowers on their loved ones' graves. (LOC.)

Freed slaves were given land at Freedman's Village by the government, where they farmed and lived during and after the Civil War. More than 3,800 former slaves, called contrabands during the Civil War, are buried in Section 27. Their headstones are designated with the word "Civilian" or "Citizen." (LOC.)

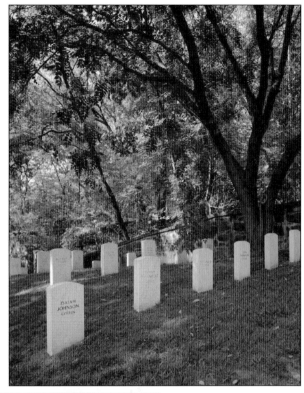

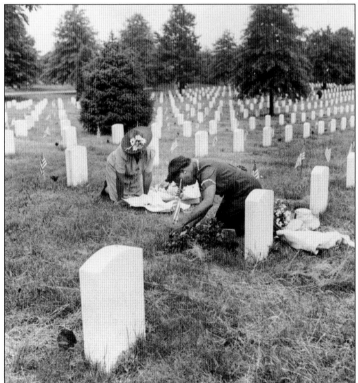

Arlington National Cemetery was segregated until 1948. Veterans of the US Colored Troops (USCT) were buried in Section 27. The 175 regiments of the USCT made up some 10 percent of the Union army. After the Civil War, soldiers in the USCT fought in the Indian Wars in the American West. (LOC.)

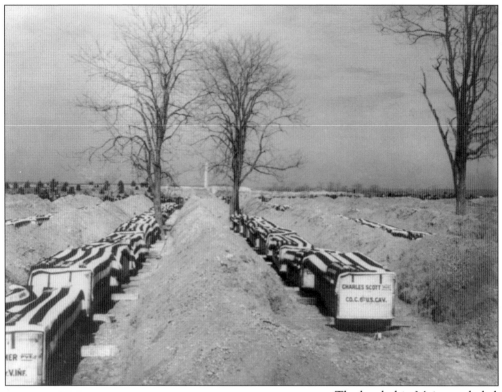

The battleship *Maine* exploded with large loss of life on February 15, 1898, precipitating the Spanish-American War. The war lasted 10 weeks. A victorious United States emerged as a world power. After the *Maine* explosion, 968 American soldiers were killed in combat and over 5,000 died of disease. (LOC.)

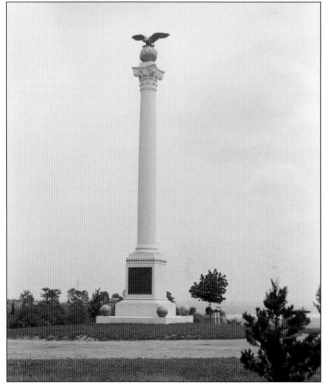

In 1900, the National Society of the Colonial Dames of America voted to place a memorial to Spanish-American War dead at Arlington National Cemetery. The monument was unveiled and dedicated on May 21, 1902. The memorial was the first national memorial erected by a national society of women. (LOC.)

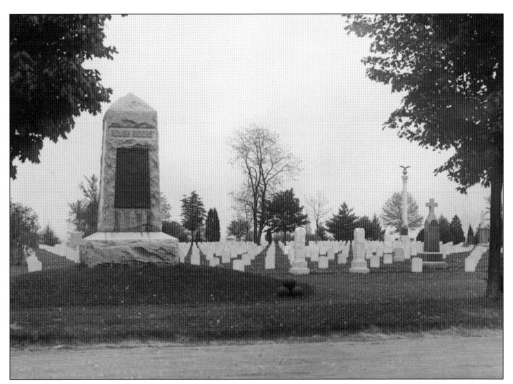

The all-volunteer cavalry regiment organized by Theodore Roosevelt and known to history as the Rough Riders gained fame for the charge up San Juan Hill during the Spanish-American War. A Rough Riders National Monument Society was organized on June 15, 1906. The Rough Riders Memorial was dedicated in 1907. (LOC.)

Construction on the Maine Mast Memorial began in late November 1913. The base of the mausoleum resembled a battleship gun turret. The mast of the *Maine* pierced the top of this structure and was set into the floor below. The Maine Mast Memorial was dedicated on May 30, 1915. (LOC.)

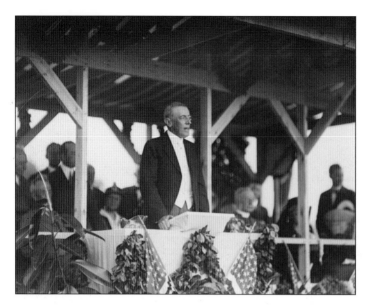

Because of the Spanish-American War, the federal government's policy toward Confederate graves at Arlington National Cemetery changed. On December 14, 1898, President McKinley announced that the federal government would begin tending Confederate graves since these dead represented "a tribute to American valor." On June 4, 1914, Pres. Woodrow Wilson dedicated the Confederate Memorial at Arlington. (LOC.)

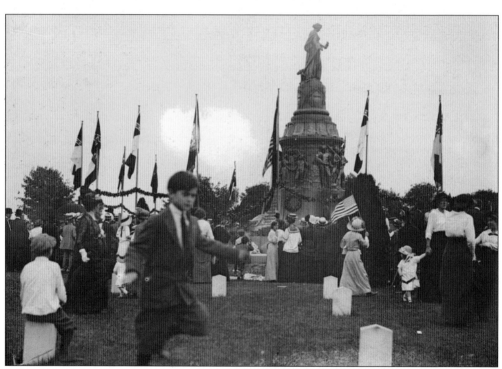

Several hundred Confederate were disinterred and reburied in a Confederate section around the spot designated for the Confederate Memorial. The Confederate Memorial was dedicated to reconciliation and the hope of a united future. US presidents have traditionally sent a wreath to be placed at the Confederate Memorial on Memorial Day. (LOC.)

America entered World War I on April 6, 1917. The arrival of fresh American troops was a tremendous morale boost to the war-weary British and French. The Americans arrived at the rate of 10,000 per day, tipping the strategic balance. The United States mobilized over four million military personnel and suffered 110,000 deaths during the war. (LOC.)

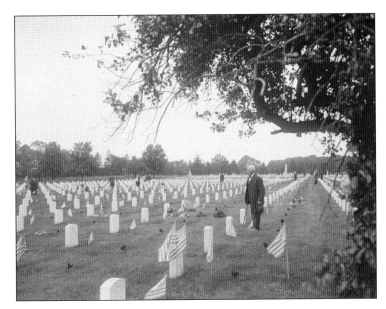

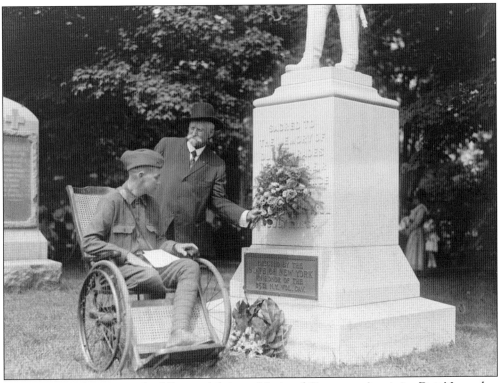

A veteran pays homage to the fallen at Arlington National Cemetery. Armistice Day, November 11, was established as a national day of remembrance commemorating the armistice signed between the Allies and Germany on November 11, 1918, marking the end of hostilities on the western front. The day was subsequently renamed Veterans Day. (LOC.)

On March 4, 1921, Congress approved the burial of an unidentified American serviceman from World War I at Arlington National Cemetery. A highly decorated soldier, Sgt. Edward F. Younger, selected from four identical caskets. The chosen unknown was transported to the United States to be placed in the Tomb of the Unknown Soldier, seen here under construction. (LOC.)

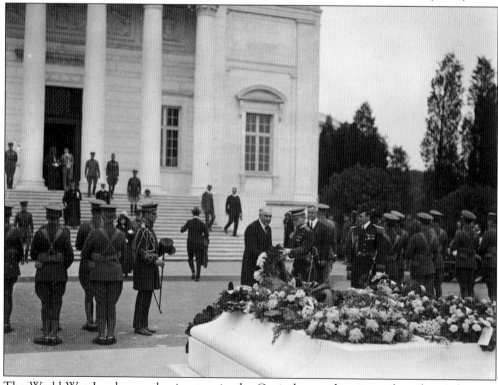

The World War I unknown lay in state in the Capitol rotunda prior to burial at Arlington National Cemetery. On Armistice Day, November 11, 1921, Pres. Warren G. Harding presided over the interment ceremonies. The Tomb of the Unknown Solider, later known as the Tomb of the Unknowns, has never been officially named. (LOC.)

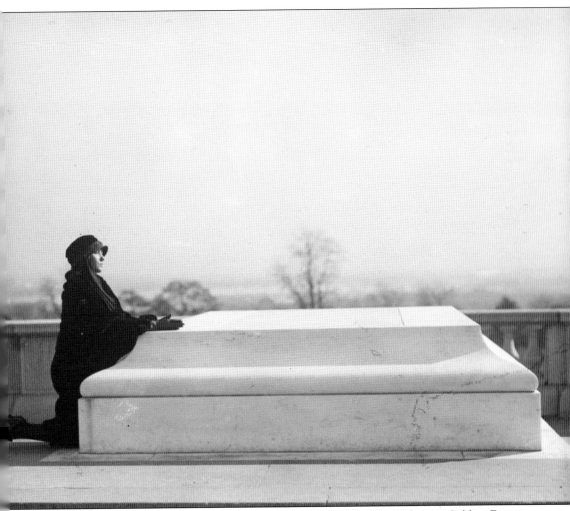

A woman seeks solace for the death of a loved one at the Tomb of the Unknown Soldier. Even in 1921, the intention had been to place a superstructure atop the tomb, but it was not until 1926 that Congress authorized the necessary funds for completion of the tomb. Architect Lorimer Rich and sculptor Thomas Hudson Jones won a design competition for a tomb that would consist of seven pieces of marble in four levels (cap, die, base, and sub-base.) The die is the large central block with sculpting on all four sides. By September 1931, all seven blocks of marble were at the tomb site. By the end of December 1931, the assembly was completed. Carvings on the central block under the direction of the sculptor Thomas Jones started thereafter. The tomb was completed in April 1932. (LOC.)

Installation of the sarcophagus for the Tomb of the Unknown Soldier is pictured here. The tomb sarcophagus was dedicated on April 9, 1932. The marble sarcophagus weighs 79 tons and is inscribed: "Here Lies in Honored Glory – An American Soldier – Known But to God." Today, the rolling hills beneath Arlington House contain the final resting places of over 400,000 American heroes. Like other grave monuments, the Tomb of the Unknown Soldier faces problems of preservation. Cracking and erosion are causing concerns for the long-term preservation of the tomb monument. A November 1963 report first recorded horizontal cracking of the monument's marble die block. In 2010, the cracks were filled, but the repairs lasted only a few months. In September 2011, the cracks were filled again. On October 21, 2011, inspection by the Army Corps of Engineers and other experts pronounced the repairs a success. (LOC.)

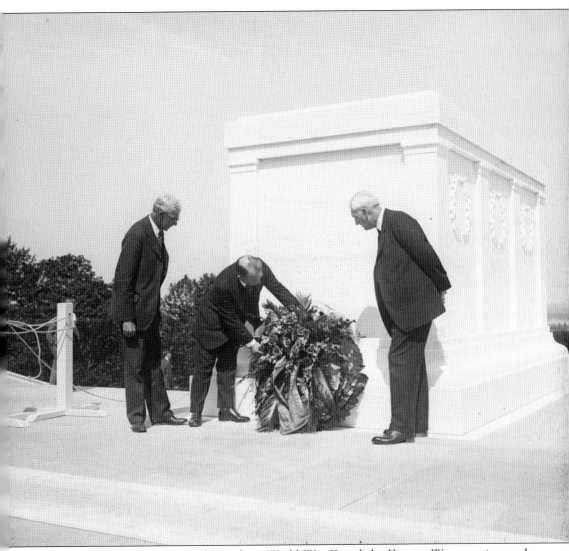

In 1958, unknown American soldiers from World War II and the Korean War were interred with the Unknown Soldier of World War I. On August 3, 1956, President Eisenhower signed a bill to select and pay tribute to the unknowns of World War II and the Korean War. The selection ceremonies took place in 1958. The World War II unknown was selected from remains exhumed from cemeteries in Europe, Africa, and the Pacific. The caskets of the World War II and Korean War unknowns were interred beside their World War I comrade on May 30, 1958. The designation of the Vietnam unknown has proven to be difficult. With improvements in DNA testing, it is possible that the remains of every soldier killed in the Vietnam War will be identified. The Tomb of the Unknowns, as it is now often called, is one of Washington's most important patriotic sites. (LOC.)

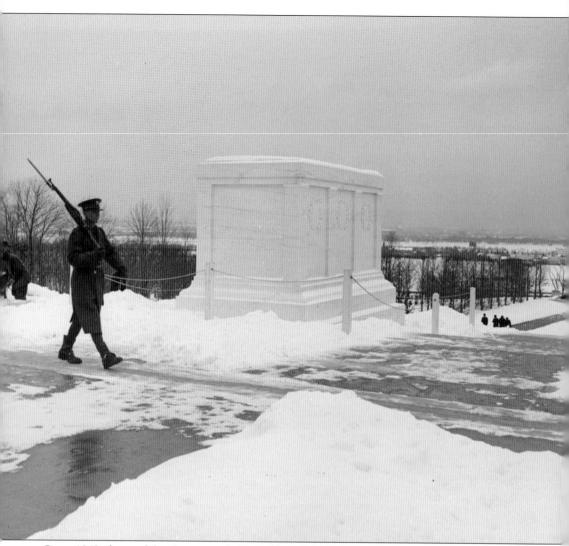

Since 1948, the tomb has been guarded by soldiers from the 3rd Infantry Regiment, known as the Old Guard. This regiment, organized in 1784, is the oldest active-duty regiment in the US Army. Part of the regiment's mission is to conduct memorial affairs to honor fallen comrades, including standard and full-honors funerals at Arlington National Cemetery and dignified transfers of fallen soldiers returning to the United States. The Old Guard is the only unit in the US armed forces authorized to march with fixed bayonets in all parades. Elements of the Old Guard serve special roles, including that of sentinels at the Tomb of the Unknowns. It is considered a high honor to serve at the tomb. Few volunteers are accepted for training, and of those only a small number pass the training necessary to become full-fledged tomb guards. (LOC.)

One of the notables buried at Arlington is Philip H. Sheridan (1831–1888) who lead the Cavalry Corps of the Army of the Potomac during the Civil War. In 1865, his cavalry was instrumental in forcing the Confederate surrender at Appomattox. Sheridan later fought Indians during the Plains Wars. (LOC.)

One of the earliest memorials to be built in the cemetery was the Sheridan Gate, named for Gen. Philip Sheridan. The gate was built in 1879 as one of the entrances to the then-walled cemetery and dedicated to Sheridan after his death. In 1971, the cemetery expanded, and the Sheridan Gate was dismantled. (LOC.)

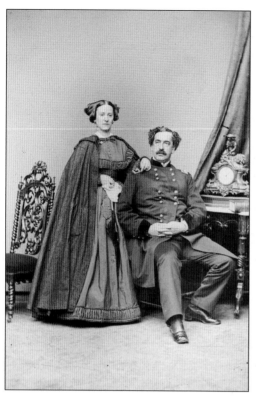

Another figure of note buried at Arlington is Abner Doubleday (1819–1893). Doubleday was a career soldier. He fired the first shot in defense of Fort Sumter. He also played a pivotal part at the Battle of Gettysburg. He is best remembered as the inventor of baseball, an honor that some contest. (LOC.)

On April 17, 1939, the Washington Senators and the New York Yankees paid tribute to Abner Doubleday. Although the game, which President Roosevelt was supposed to open, was put off because of drizzling rain, both teams journeyed to Arlington National Cemetery to lay a wreath at the grave of baseball's founder. (LOC.)

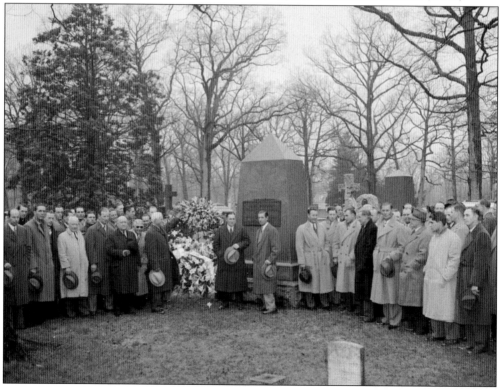

Another notable individual buried at Arlington is George R. Crook (1830–1890), who fought during the Civil War and the Indian Wars against both the Sioux and the Apache. Crook commanded one of the columns during the 1876 campaign against the Sioux that resulted in the massacre of Custer's troops at Little Bighorn. Crook later fought against Geronimo. (LOC.)

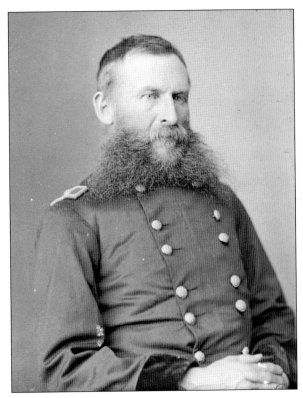

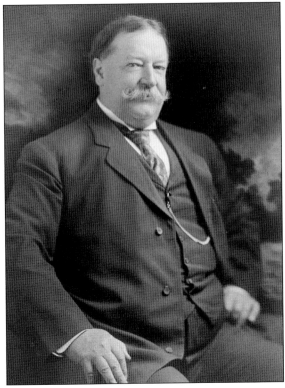

William Howard Taft (1857–1930), the 27th president of the United States and later the 10th chief justice, is buried in Arlington Cemetery. Taft is the only person to have served in both offices. Taft and John F. Kennedy are the only US presidents buried at Arlington. (LOC.)

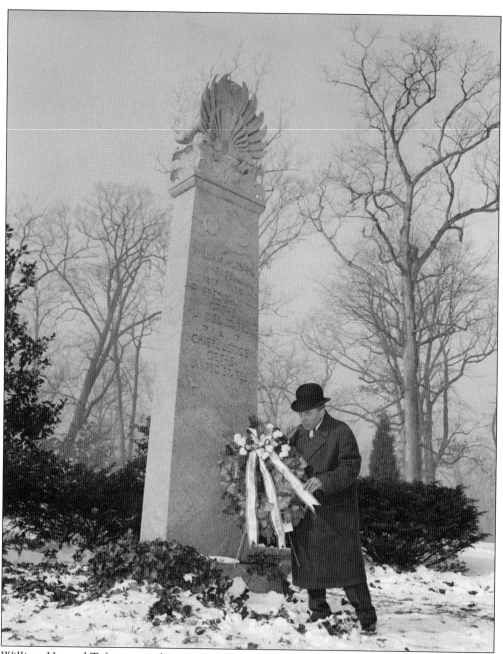

William Howard Taft is not only one of two presidents buried at Arlington National Cemetery, he is also one of four chief justices buried there (the others are Earl Warren, Warren Burger, and William Rehnquist). Taft was the first president to throw out the baseball at a season opener, in a game between the Washington Senators and the Philadelphia Athletics in 1910. Taft's wife, Helen Herron Taft, who died in 1943, was instrumental in bringing Japanese cherry trees to Washington, DC. A 14-foot-tall granite monument, inspired by ancient Greek burial steles, marks the graves of Taft and his wife. Helen Taft arranged for James Earl Frazer, a New York sculptor, to design this private monument for the grave. The design was approved by the Commission of Fine Arts and the secretary of war. It was erected by the Taft family in early 1932. (LOC.)

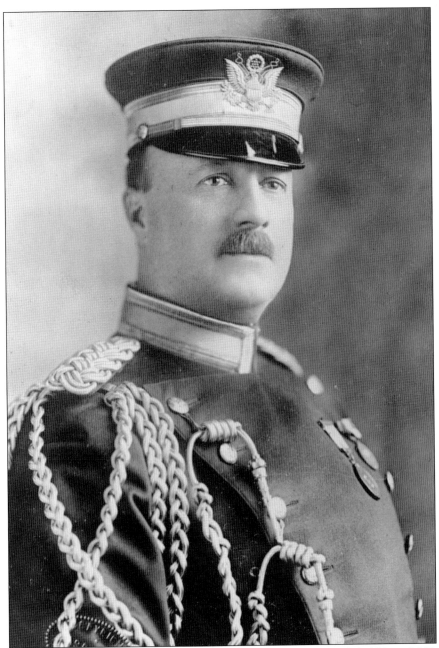

One of the notables honored at Arlington National Cemetery is Maj. Archibald Butt (1865–1912). Butt was the military aide to both Pres. Theodore Roosevelt and Pres. William Howard Taft. Butt and his housemate, painter Francis Davis Millet, died during the sinking of the *Titanic*. Butt was universally recognized for his heroic conduct during the tragedy. His body was never recovered. President Taft, who had come to regard Major Butt "as a son or a brother," praised him as a Christian gentleman and the perfect soldier. Taft wrote, "I knew that he would certainly remain on the ship's deck until every duty had been performed and every sacrifice made that properly fell on one charged, as he would feel himself charged, with responsibility for the rescue of others." At a May 5 ceremony, Taft broke down weeping, bringing his eulogy to an abrupt end. (LOC.)

As the *Titanic* sank, the crew prepared the lifeboats, and Major Butt helped in the rescue efforts. One survivor described him as calm and collected, "Major Butt helped . . . frightened people so wonderfully, tenderly, and yet with such cool and manly firmness. He was a soldier to the last." A cenotaph was erected in the summer of 1913 by his brothers in Section 3 at a point that Major Butt had previously selected as his gravesite. The Butt-Millet Memorial Fountain, a private memorial fountain, located in the President's Park, adjacent to the White House, was dedicated in October 1913. Powerful friends argued that Butt (who was an aide to the president) and Millet (who was vice chair of the US Commission of Fine Arts at the time of his death) were both public servants who deserved to be memorialized separately from private citizens who died in the *Titanic* disaster. (LOC.)

Another prominent military man buried at Arlington is John J. Pershing (1860–1948), seen here posing for a sculptor. Pershing led the American Expeditionary Force in World War I, 1917–1918, insisting that American units not be put under British or French command as replacements but that they fight as independent units under American command. (LOC.)

Pictured here is the funeral of General of the Armies John J. Pershing. A caisson bearing the remains of the general moves slowly in the funeral cortege, which has just departed from the Capitol (shown in background) for Arlington National Cemetery, where last rites took place on July 19, 1948. (LOC.)

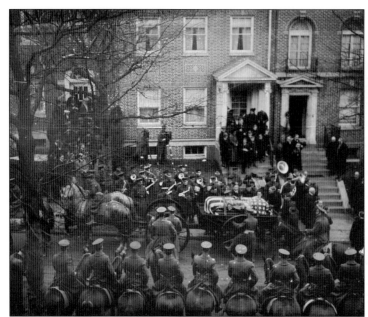

Robert E. Peary (1856–1920), an American explorer who claimed to have reached the North Pole on April 6, 1909, is also buried in Arlington. Peary's claim was widely credited for most of the 20th century. The first undisputed explorers to reach the North Pole were documented in 1969. Peary's funeral in 1920 is seen here. (LOC.)

Assistant Secretary of the Navy Ernest L. Jahncke paid tribute to Rear Admiral Peary in 1929 on the 20th anniversary of the discovery of the North Pole. Ceremonies were conducted at the grave of the explorer. Some historians believe that Peary was guilty of deliberately exaggerating his accomplishments. (LOC.)

Another adventurer, Richard E. Byrd (1888–1957), a pioneering American aviator and polar explorer who reached both the North and South Poles by air, is buried in Arlington Cemetery. Rear Admiral Byrd is seen here with Pres. Franklin Roosevelt. By the time of his death, Byrd had received nine citations for bravery, including the Medal of Honor. (LOC.)

One of the notables buried at Arlington is Omar Bradley (1893–1981). Bradley commanded all US ground forces after the Normandy invasion in 1944. He commanded some 1.3 million men. Bradley is one of only nine people to ever have held five-star rank. (LOC.)

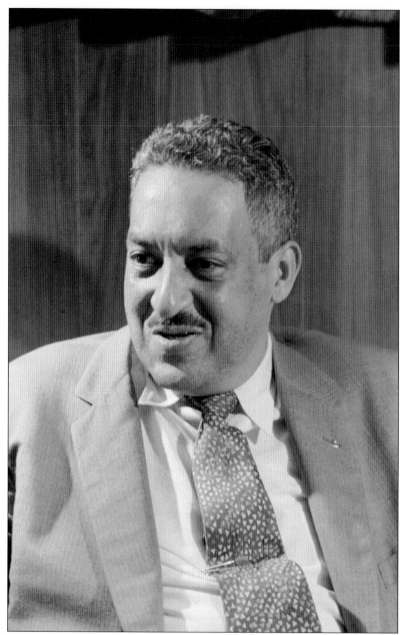

Thurgood Marshall (1908–1993), the first African American appointed to the Supreme Court, was interred in Arlington. Marshall was a lawyer known for his high success rate in arguing before the Supreme Court and his advocacy during the landmark 1954 Supreme Court case *Brown v. Board of Education*, the decision that desegregated public schools. Marshall challenged the legal underpinning of racial segregation, the doctrine of separate but equal established by the 1896 Supreme Court case *Plessy v. Ferguson*. On May 17, 1954, the Supreme Court unanimously ruled that "separate educational facilities are inherently unequal," and therefore racial segregation of public schools violated the equal protection clause of the 14th Amendment. *Brown v. Board* provided the legal foundation for the civil rights movement and established Marshall as one of the most prominent lawyers in American history. (LOC.)

Five

ART, SYMBOLS, AND PHILOSOPHY

Matters of life and death converge at a cemetery. In death, the everyday distinctions of race, class, and religion disappear. Cemeteries are where the rich and the poor, the young and the old, the famous and the not-so-famous come together in the end. As one tombstone elegy from Lake Ridge in Prince William County intones, "Remember reader as you pass by, as you are now so once was I, as I am now you must be, prepare for death and follow me."

Those who conceived the idea of the modern cemetery anticipated the movement for public parks. Cemeteries provided the public with beautiful outdoor gathering spaces during a time when parks were scarce. Out of the movement to beautify cemeteries arose a custom of gathering in these new public spaces. Families picnicked near gravesites, and children played there. Somewhere along the way, this practice fell by the wayside. The appreciation of cemeteries has made a comeback in the digital age. Many genealogists have been using the Internet and GPS systems to locate the graves of long-lost ancestors. This renewed interest in cemeteries has spread to an interest in photographing tombstones, the growth of in-depth historical research, and even cemetery tourism.

Historic cemeteries are a treasure trove of art, biography, and philosophy, one's last chance to shout out to posterity: "This is who I was, this is what was important to me." Art, symbols, and inscriptions are called upon to succinctly capture the essence of life in a beautiful and meaningful way.

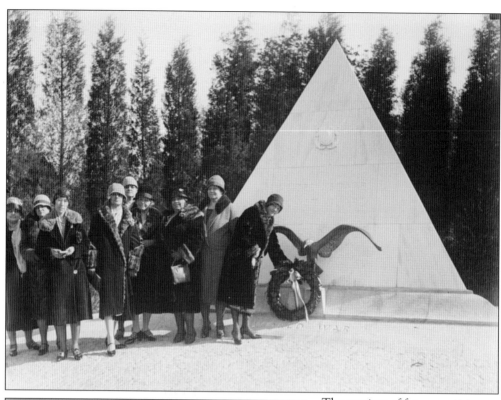

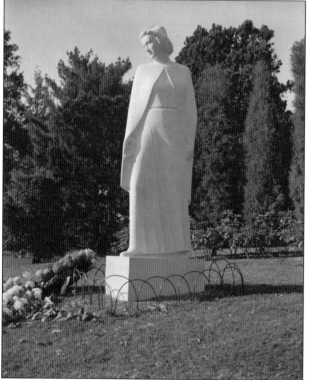

The services of famous artists are often engaged in the erection of public memorials. At Arlington National Cemetery, architect George Howe and sculptor Gaston Lachaise captured the spirit of the Coast Guard's legendary steadfastness. A bronze seagull, poised with its wings uplifted, alights below the Coast Guard motto, *Semper Paratus* (Always Ready). (LOC.)

Collective memorials to particular groups of the dead have long been erected. The granite statue of a nurse in uniform, sculptured by Frances Rich, honors the nurses who served in the US armed forces, many of whom are buried in Section 21 of Arlington National Cemetery—also called the "Nurses' Section." (LOC.)

A competition was held to select the sculptor of the Confederate Memorial at Arlington National Cemetery. Moses Ezekiel won the competition and titled his work *The New South*. The monument's focus is on peace and the future, and its repetitive images focus on the sacrifices made by the common soldier. (LOC.)

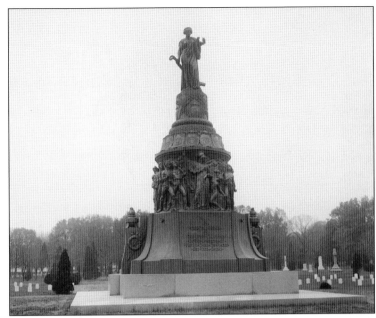

The Fountain of Faith, at the National Memorial Park Cemetery in Falls Church, is the work of famous Swedish sculptor Carl Milles and represents the communion and reunion of family and friends. The bronze figures capture the joy and strength of love in all human relationships, rising above earthly limits. (LOC.)

Even works of art sometimes perish. In 1884, a Temple of Fame was erected at Arlington National Cemetery. Materials from the demolished US Patent Office Building were used. Unfortunately, there was not enough marble to build the dome, so a tin dome (made to look like marble) was installed instead. The Temple of Fame was demolished in 1967. (LOC.)

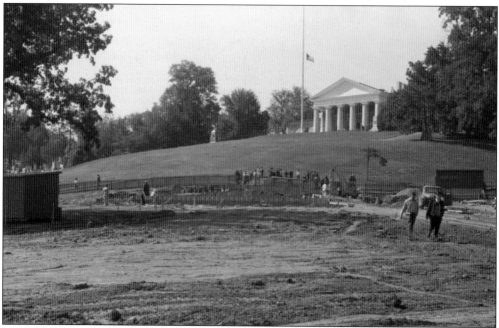

State-of-the-art inventions are sometime used at gravesites. President Kennedy's grave at Arlington National Cemetery (seen here under construction) is marked with an eternal flame. The burner is a specially designed apparatus. A constantly flashing electric spark near the tip of the nozzle relights the gas should the flame be extinguished by inclement weather. (LOC.)

Funeral flowers are rich in symbolism. White lilies symbolize innocence, virtue, and purity. They symbolize the idea that the departed has returned to an original state of innocence. The circular funeral wreath, such as the one seen on the right, symbolizes the circle of life and is a symbol of eternal life. (LOC.)

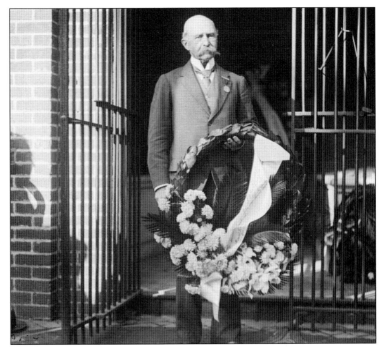

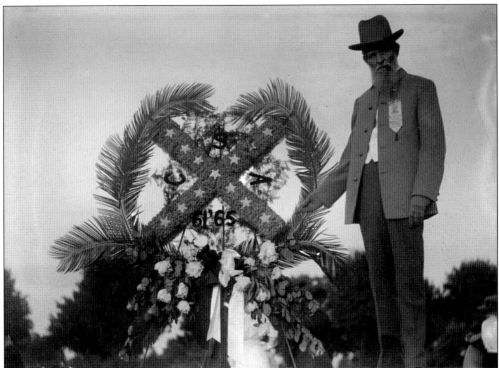

Flowers have a symbolic and aesthetic significance. Used since the time of the ancient Egyptians, flowers are symbolic not only of love and sympathy but also of eternity and immortality. Flowers attest to the transitory life of man. There is profound religious symbolism in the very fact that flowers do not last forever. (LOC.)

Biography often plays an important role in gravestone inscriptions. The tombstone of Mary Packard at the Ivy Hill Cemetery in Alexandria relates that she was a missionary in Brazil. Little else is known about her life, but this bit of biographical information imparts what she thought was the most important aspect of her life. (AC.)

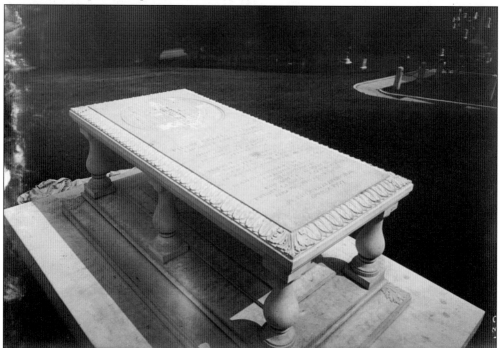

Unlike most people, Pierre Charles L'Enfant received biographical recognition on his tombstone only long after his death. L'Enfant died in 1825 and was buried on a Maryland farm. In 1909, he was reburied at Arlington National Cemetery in a tomb inscribed, "Engineer-Artist-Soldier Under the Direction of George Washington Designed the Plan for the Federal City." (LOC.)

Prizefighter Joe Louis wanted to be remembered as a world champion. His gravestone at Arlington National Cemetery portrays Louis in a fighting stance and is inscribed, "The Brown Bomber / World Heavyweight Champion / 1937–1949." Louis died in 1981 and continues to be known as one of the greatest prizefighters of all time. (LOC.)

The tombstone of Launcelot Minor Blackford at Ivy Hill Cemetery captures a wealth of biographical information, including his service in the Confederate army and his long tenure as the principal of the Episcopal High School in Alexandria. It also captures the essence of the man: "servant of the Lord, gentle, patient, an apt teacher." (AC.)

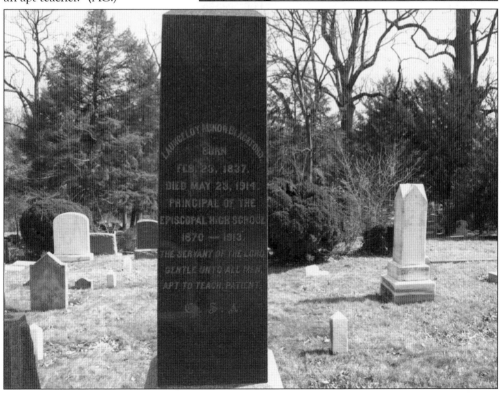

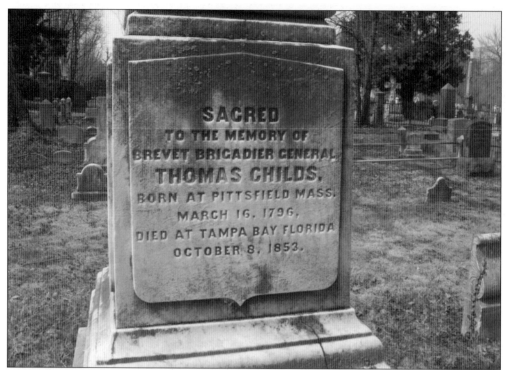

The tombstone of Thomas Childs, at the Wilkes Street Cemetery Complex, states that he was a brevet brigadier general. A brevet granted a commissioned officer a higher rank title as a reward for gallantry but did not give more authority, precedence, or pay. It should not be confused with the temporary commissions given during the Civil War. (AC.)

An obelisk is made of four rectangular sides that taper toward each other and are capped by a pyramid. Obelisks rose to popularity in the United States during the age of Egyptian Revivalism, which began during the late 1700s. At this time, obelisks began to symbolize fatherhood, strength, and power. (LOC.)

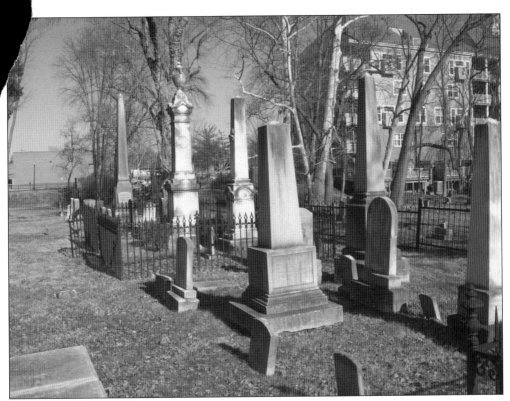

Obelisks became very popular grave markers by the end of the 19th century. Obelisks were more expensive than smaller and plainer gravestones and so served as a means of displaying family wealth and importance. Historians can mark the relative wealth of various congregations at the Wilkes Street Cemetery Complex by counting the number of obelisks. (AC.)

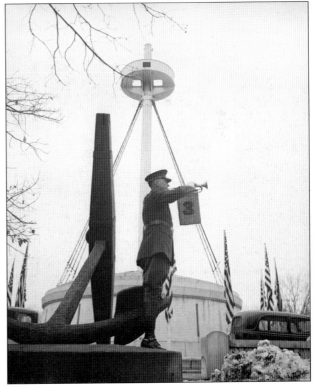

Music expressing mourning or grief is an important part of the funeral process. "Taps" is the piece of music most likely to be heard at cemeteries. Written by Union brigadier general Daniel Butterfield in 1862, this musical piece is played at dusk and funerals, particularly by the US military. (LOC.)

The preservation of historic cemeteries is an ongoing challenge. In October 2008, the Fairfax County Cemetery Preservation Association, Inc. was founded to protect the hundreds of family cemeteries in the county. Typical tasks include removing brush, trash, dirt, and algae from tombstones with soft toothbrushes and distilled water. (AC.)

Preservationist strategies are largely aimed at educating property owners and providing them incentives to protect heritage resources under their control. Lack of public awareness and funds are the biggest problems facing historical preservationists. The goal of preservationists is to record the locations of graves and, when possible, preserve them in place. (AC.)

Tombstones are sometimes inscribed with bits of philosophy. Harold Snowden (1836–1901) served as a surgeon in the Confederate army. Later, he was a surgeon and editor of the *Alexandria Gazette*. He is buried in the Wilkes Street Cemetery Complex. The epitaph on his tombstone reads, "He Stood Four Square to Every Wind That Blew." (AC.)

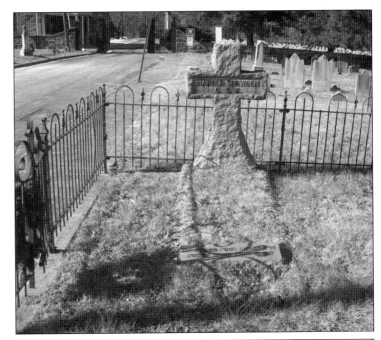

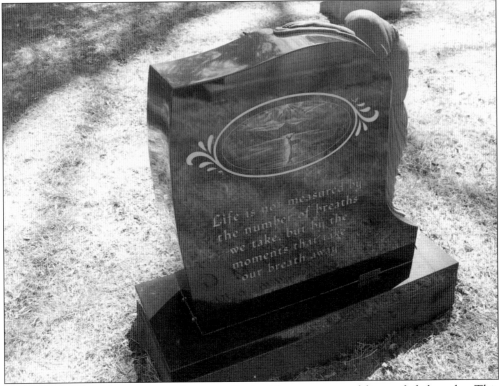

Contemporary tombstones are often inscribed with very personal lines of philosophy. This gravestone in Fairfax City exhorts, "Life is not measured by the number of breaths we take, but by the moments that take our breath away." A nearby tombstone muses, "Don't cry because it's over. Smile because it happened." (AC.)

Discover Thousands of Local History Books
Featuring Millions of Vintage Images

Arcadia Publishing, the leading local history publisher in the United States, is committed to making history accessible and meaningful through publishing books that celebrate and preserve the heritage of America's people and places.

Find more books like this at
www.arcadiapublishing.com

Search for your hometown history, your old stomping grounds, and even your favorite sports team.